ON BEING A PHOTOGRAPHER

ON BEING A PHOTOGRAPHER
■ *A Practical Guide* ■

David Hurn/*Magnum*
in conversation with Bill Jay

LensWork
PUBLISHING
2003

We should like to place on record our gratitude, admiration and respect for all those fine photographers who have given so generously of their thinking, time and talent — and especially their images — to further our quest for an understanding of the medium's basic working principles. Many of these individuals are mentioned in the text but a complete list would fill this book.

Our grateful thanks, also, to Jo Ann Briseño, a specialist in the World Wide Web, who took the time and patience to process our notes into a presentable and publishable form.

Third Edition, Second Printing, September 2003

ISBN #1-888803-06-1

Library of Congress Catalog Card Number : 97-075635

Published by LensWork Publishing, 909 Third Street, Anacortes, WA, 98221-1502 USA

Printed in Canada

CONTENTS

INTRODUCTION

This conversation celebrates 30 years of friendship and of a continuous, and continuing, dialogue about photography.

We have attempted to summarize our agreements on what we consider the fundamental characteristics of the medium and how they can be employed by photographers for more effective growth as image-makers and as human beings.

In that sense this is a how-to-do-it book, although it is not about technology or processes. It is a book on *how to think and act like a photographer,* culled from practical experience and from the lives of many fine photographers of the past and present. We have concentrated on the common denominators in these approaches to the medium in order to discover basic principles which can be employed by all photographers in whatever band of the photographic spectrum they reside.

Because our conversations have been so voluminous over such a long period of time it is impossible to differentiate who said what, and when. Our opinions, attitudes and ways of thinking, although originating from widely different perspectives — David's from professional practice, Bill's from history and criticism — merge into a seamless whole. One example will illustrate how this happens.

Many years ago, one of us gave a lecture on "What is Photography?" [David: it was me. Bill: yeah, yeah, I know it was]; the other one heard it, was impressed by the clarity of thinking, and adopted it — then adapted it, made rearrangements, added new images and ideas and gave it publicly with the original lecturer in the audience. He picked up on the adaptations, modified them and gave another lecture. The other one used his modifications which suggested other images and ideas… and so it has continued. Today, it would be difficult to separate the genesis of any of the ideas, issues or images! This is not to imply that we agree on everything. Nevertheless, we have emphasized our agreements in the belief that they are more likely to provide practical solutions for photographers.

In order to provide the basic text for this book we taped 12 hours of conversation, which were supplemented by published writings by both of us, letters back and forth, and a discussion of the first drafts. We offer the conversation in the hope and conviction that photographers can lead lives more charged with meaning through the application of these principles.

True, this is a book about photography — but photography is about life. We both agree with the psychologist Abraham Maslow that the purpose of life is to become actually what we are potentially. We believe photography offers an ideal vehicle towards this destination.

David Hurn
Bill Jay
1996

About the Photographer
David Hurn

Thirty years ago I first showed David Hurn my photographs, the results of more than seven years of struggle to be a photographer. It took him about 30 seconds to look through the lot and deliver his judgment: boring. "Derivative," he said. "You won't make it."

We have been friends ever since.

And he has continued to be my goad, my conscience, my adviser and, best of all, my fiercest critic. Do you know how rare, how valuable, is such a friend, whose devastating frankness is wholly welcome because it is abundantly evident that such criticism taps the wellsprings of love and not competitiveness, petty jealousies or self-aggrandizement?

Of course, I do not always agree with his opinions or follow his advice and, even here, in the spurning of his best intentions, David Hurn is supportive, as if to say: "He asked for my opinion; I gave it my best shot; but the decision is his to make."

I tell you these facts, and will relate the circumstances of our first meetings, because David Hurn's candor permeates these pages. Nowhere else that I know of will photographers meet in print a mentor who can or will speak with such directness and relevancy to the step-by-step issues which are always present in the medium, but rarely discussed.

Perhaps I should be equally direct with the reader. David Hurn, like any other great photographer, has an agenda which is not at all hidden. He believes passionately in a particular approach to the medium — his approach. He advocates a very specific way of thinking and working as a photographer because he has committed his professional life to a singular band of the photographic spectrum, what he would call reportage, or eye-witness photography. It is therefore fair to ask: just how relevant is this book to photographers who intend to reside in any one of the other multi-hued bands of the spectrum which together make up the medium we call photography?

I would assert its relevance and usefulness to all photographers for many reasons, among which would include: the importance of clear thinking in developing an intellectual rationale for any method of working; the emphasis that the subject, the thing itself, is the genesis of all types of photography; the insistence that a clarity of vision is aided by clarity of mind; the greater appreciation of other photographers' work which comes from understanding their philosophical underpinnings (even photographers are viewers of photographs as much as

takers and makers); the assertion that humanism is inseparable from art, however defined or created; the demonstration that there is no substitute, in any endeavor, for commitment and hard work.

Nevertheless, it is true that David Hurn's commentary will be of special relevance to photographers who believe that there is no greater thrill or satisfaction (or frustration) than confronting people and places, and, from that heady, chaotic flux of life, selecting images of direct simple beauty and truthfulness.

This is charged language! Beauty? Truthfulness? I am aware of the danger in introducing these words so early in our narrative, but, do not fear, I expect them to become more comfortable as they become more familiar.

But right now we have a more pressing need. I want to introduce you to the person who will give you guidance *On Being a Photographer*…

EARLY LIFE

David Hurn was born in Redhill, Surrey, England, on 21 July 1934. Technically, therefore, he is an Englishman — but that is a quirk of circumstances. By genes, temperament and choice he is a Welshman, from his primary school education in Cardiff to his present home in Tintern, where he lives in a 600-year-old stone cottage overlooking the river Wye, backed by continuous falls of water trickling over and around the steep banks of his terraced garden. A short walk down river are the ruins of the early 12th-century Tintern Abbey, celebrated by William Wordsworth in his famous poem of 1798. The river is flanked by meadows and woods where David used to ramble with his

dogs which accompanied him on his photographic expeditions around Wales.

Tintern is rooted in the distant past. Its pastoral sleepy beauty clashes with the raucous machines driven through its narrow main street; old sheep farmers live cheek-by-jowl with artists and stockbrokers; weathered stone cottages built by manual labor now house fax machines and computers; it is a place called home and a tourist mecca. These clashes of old and new, rich and poor, ancient and modern, are a microcosm of the changes taking place in Wales and reflect the underlying themes of David Hurn's incessant imagery.

During his schooldays David was not considered a promising student: far from it. He emerged from his education with no qualifications for anything, due to a form of what is now known as dyslexia. "No one understood the term or the condition in those days," says David, "and so you were just 'thick' [stupid]." It was impossible for him to cope with the written examinations which, then more than now, were essential in any subject, especially the sciences, and which were requisites for the life of a veterinarian, his aspiration. But David did excel in sports, particularly track events and rugby. When he reached the age when every British male youth was required to spend two years in the armed forces (National Service) his sporting prowess helped to secure for him a place at the prestigious Royal Military College, Sandhurst, the training ground for British Army officers. It seemed that David was destined to follow in the footsteps of his father, Stanley, as a career soldier. Stanley had volunteered for the Welsh Guards just before the outbreak of World War II in 1939 and rose rapidly through the ranks to become a major

in Special Operations. This was a remarkable achievement and one which the son might have emulated.

Photography changed all that.

FIRST PHOTOGRAPHS

Ever anxious to gain more freedom from the rigid, cloistered and spartan life of the Sandhurst cadet, David noticed that the only students allowed outside the college were members of the camera club — the darkrooms were located near the local town. Buying a camera had nothing to do with a love of photography, but it was merely a passport to freedom. Unfortunately, he was required to take at least some token pictures for the college noticeboard which necessitated actually loading the camera with film! David bought a cheap little how-to-do-it book (probably one of the Focal Guides so popular at the time) and taught himself the rudiments of photography. He still believes in the efficacy of this solitary education. "In my opinion there are two efficient ways to learn: apprentice yourself to a top professional or teach yourself. The problem with photography is that everyone does it, believes he/she does it well (and would do it better if only he/she could buy a better camera or take more time off) and so this individual produces bad pictures because he/she is doing everything wrong but passes on bad advice out of ignorance. The problem with receiving bad advice is that you do not realize that the advice is bad when you are a beginner, and the bad habits become ingrained and very, very difficult to remove. My advice is: learn from the best or teach yourself. And do not bother at all if you do not have an exaggerated sense of curiosity."

After absorbing the instructions in his guide-book, David began to record the daily life of his fellow cadets. This led in turn to looking at published photographs more carefully, and he discovered a clash between the messages of the images and of his military officers. In particular, a photo-essay on Russia by Henri Cartier-Bresson, although David was ignorant of the authorship at the time, published in *Picture Post* (29 January, 5, 12, 19 February 1955) and in other magazines including *Life*, seemed to contradict the propaganda he was being force-fed by the college's instructors, and the weight of evidence was in favor of the images.

One image struck him most forcibly: it showed a Russian soldier in a department store buying a new hat for his wife. "I remember most distinctly accompanying my parents on a shopping trip to Howells [a smart department store in Cardiff] as soon as my father had returned from the war. I was about eleven. And he bought my mother a hat. My memory of that event and the emotion of the Russian picture were identical. I had been led to believe that all Russians were desperately poor and grotesquely belligerent, yet here was a Russian who seemed to be reasonably affluent, at least with enough spare cash to buy his wife a gift, and who was displaying human emotions of tenderness and caring. This image had the touch of authenticity. It felt real and true." David began to question and challenge his teachers, skilled practitioners in propaganda, and soon developed a distinctly suspicious attitude towards the military. "What I saw in my viewfinder and in published images," he says, "made me profoundly pacifist"; hardly an encouraging trait in a future military officer.

The Army and David Hurn mutually agreed that he wasn't suited to a soldier's life.

In 1955, David Hurn had exchanged a rifle for a camera and determined that he would be a photographer.

REFLEX

To that end, David moved to London, secured a job (selling shirts in Harrod's, the ritzy West End store patronized by Royalty) and met a man at an exhibition who was to be a major photographic influence in his life: Michael Peto.

The exhibition was at the Institute of Contemporary Arts, then situated behind the National Gallery, and featured a rare show of photographs, by the photographer responsible in large part for David's disaffection for the military, Henri Cartier-Bresson. David's intensity of focus on the images attracted the attention of another visitor on that day, and Michael Peto, already a leading British photographer, introduced himself to the earnest young man. Peto was a charming Hungarian, and, in his still-thick European accent, began talking about pictures — and asked to see David's efforts, after which he offered his help.

Peto was in the perfect position to help a young photographer. He was a member of a small photographic agency called Reflex, which comprised Peter Tauber, the organizer and marketing manager, George Vargas, a fine news photographer, and Peto himself, who specialized in warm, lyrical images which were regularly published in *The Observer,* a respected British Sunday paper.

David Hurn was adopted by the agency. Its members gave him much advice, taught him the business side of photography and, gradually, passed on more and more evening and weekend assignments. Much of this work was photographing British Royalty, already a major money-maker for the agency. "The idea that the Royal watch by paparazzi is a recent phenomenon is nonsense," says David. "I was soon spending every weekend photographing the Royal doings, such as Prince Philip baring his chest while changing shirts at a polo match, or Princess Margaret with her beau, Captain Townsend, and so on. Reflex owned one of the first long telephoto lenses in the country and in those days the ability to shoot close-ups from a distance was unsuspected, so we got a lot of scoops. But I was fed up. I didn't feel like a photographer. I spent most of my time sitting on my butt waiting for the Royals to get off theirs." David Hurn was 22 years of age and anxious for experience.

HUNGARY

His close friend of the time was John Antrobus, whom he had met at Sandhurst. They quit the Army at the same time and decided to share an apartment in London. Antrobus wanted to be a writer. Both of them spent much of their leisure time in the coffee bars where talk of politics was rife — and much of the talk of the time was about the Hungarian Revolution.

Hungary had been Nazi Germany's ally in World War II and was occupied by Russia at the cessation of hostilities in 1945. It soon turned communist (1949) and its puppet regime became increasingly oppressive, leading to a popular uprising in 1956 which was quickly and brutally suppressed by Russian troops.

Hurn and Antrobus (a photographer with very few published pictures and a writer with no published articles) decided to go to war. "It was a decision based more on 'What a lark' than on any serious involvement," David remembers. The young men hitch-hiked across Europe to Austria, sat in cafes near the Hungarian border, which they eventually crossed in the back of an ambulance, and hitch-hiked yet again to Budapest. They were in, but unsure of what came next.

As in most civil disturbances, especially in large cities, the action was spasmodic and localized. It would have been relatively easy to spend all the time being in the wrong street or in the right street at the wrong time. Fortunately they met a seasoned correspondent, Eileen Travers of the *London Daily Mail*, who took the young photographer under her wing and briefed David on what was happening, where, and when. She also introduced him to correspondents from *Life*, the premier market for photojournalists at the time, which put David under contract on the spot — and arranged to get him out of Hungary.

His images were not only published in *Life* magazine but also in many other newspapers and periodicals, including *Picture Post* and *The Observer*, through distribution by Reflex. "There's nothing like starting your photographic career at the top!," says David. He is self-deprecating about his luck but the fact remains that he did make the effort to get to the situation and he did shoot pictures which were acceptable to the top picture journals of the world.

Unfortunately this was at a time when it was usual for periodicals to retain all copyright to published work and to retain ownership of the negatives. As a consequence, practically all David's coverage of the Hungarian Revolution has been lost; he has been able to find only three prints from which he has made copy negatives. "The loss of my work is largely the reason why my memory is so hazy of this period in my life. I can vividly recall the situations surrounding those three images, but not much else. Contact sheets would have acted as powerful memory triggers, bringing back with full clarity the thoughts, feelings, as well as the sights, of those days."

Back in London, flush with the success of the Hungarian pictures, David quit his job at Harrod's and became a full-time photographer. Initially he continued to be nurtured by Reflex, which provided him with a small retainer plus a percentage of sales. But within a year he had severed connections with the agency and was freelancing for many newspapers and magazines, covering a wide variety of events mainly of topical newsworthy interest. He was not alone, of course. He would keep meeting the same small group of enthusiastic young photographers at many of the events, and they became fast friends as well as rivals. "I do not remember any animosity," says David, "only cooperation which spurred growth in us all." This group included Don McCullin, Ian Berry, and Philip Jones-Griffiths, who together with David Hurn would become members of Magnum Photos at about the same time. Never before in Magnum's history had a single group from one city all become members more or less simultaneously.

But that was still in the future. In 1957 David decided to go to Russia.

RUSSIA

In a newspaper article on life in Russia, the reporter seemed to hedge his account by stating that everyday existence could only be guessed at because no photographer had lived with a Russian family. That was all the incentive David Hurn needed. He made his way to Leningrad, reasoning that a university town should have some English speakers among the student population. He presumed correctly. Loitering around the university he asked: "Do you speak English?" until he received an affirmative and then invited himself back to the young man's home. From there, he telephoned *The Observer*: "I'm a photographer living with a Russian family. Will you keep me here?" The answer was "Yes," and David Hurn's photojournalism career received another boost ...

On his way out of Russia, David learned that Finland's national composer, Jean Sibelius, had died. He covered Sibelius' funeral, again for *The Observer*.

Hungary, Russia, Finland ... all important stepping-stones in Hurn's burgeoning career, but in many ways the 50s phenomenon of the coffee-bar as a meeting place of young, politicized intellectuals was even more influential. David remembers one place in particular, *The Nucleus*. "It was an extraordinary meeting place, loud with music from all over the world, but with a strong streak of impromptu jazz, raucous with passionate conversation, and reeking of spaghetti. It was run by Gary Winkler, who doubled as both drummer and the chef, whose spaghetti was not only delicious but incredibly cheap. I hung around with a group of friends which included the film director Ken Russell, who was then still a ballet dancer, the actress Shirley Ann Field, the philosopher Colin Wilson, the writer Stuart Holroyd, the film cameraman Walter Lassally, and John Antrobus who never wrote anything about Hungary, as far as I know, but was beginning to make a name for himself as a comedy script writer."

Chains of circumstance spread out from these friends and led David into areas of photography which were as unexpected as they were invigorating.

FILM AND FASHION

For example, Ken Russell was making the transition from ballet dancer to still photographer to filmmaker. His still work presaged the outrageous theatricality of his later films. "He would take these absurd ideas," remembers David, "and shoot bizarre pictures which would end up in a magazine like *Illustrated*. One story, for example, was about riding a penny-farthing bicycle up the Albert Memorial!"

One of Russell's first films, made with a wind-up Bolex, was *Amelia and the Angel*, which opened the door to working with the BBC program, *Monitor*. One of the first television films was about David and his friends who shared an apartment in a house run by a strange old lady. The result was *A House in Bayswater*. Ken Russell was constantly on the lookout for fresh ideas. And David Hurn's life seemed just bizarre enough! David had a strange cross-section of friends, lived in a weird house, had photographed war and a Royal bare chest and famous people and strippers and high fashion (as we will discover later) and seemed ready-made to be yet again a star in a Ken Russell movie. The biggest problem was who to get for the female lead, whom the script described

as "the most beautiful woman in the world." Shooting was about to begin and no decision had been made. Claire Bloom, an already famous stage and screen actress, had agreed to take a role but the director and David both felt the lead should be given to an unknown. Who and where was she?

The question had not been answered when David had to go to Paris to photograph the collections for *Jardin des Modes*. On the last day David walked into the hotel lobby and saw "the most beautiful woman in the world" who was a fashion model, also working at the collections. David walked up to her, told her she was "the most…," asked her to star in a movie, which starts shooting tomorrow, and "you must come back to London with me today!" She laughed. Eventually David's persistence convinced her at least to call her agent, who confirmed the arrangements, and Alita Naughton became the female star — and David's wife in 1964. The Ken Russell movie, *Watch the Birdie*, was shown on British television but a third of it has since been lost. When Ken Russell made his first film for distribution, *French Dressing*, he insisted that Alita was given the lead. But this was the only movie that Alita would agree to make. David and Alita have one daughter, Sian (pronounced Sharn); they were divorced in 1971.

During the early 1960s a series of seemingly trivial events had later similarly profound repercussions in David's life. One of them led to his short-lived career as a fashion photographer.

It began with a seemingly simple assignment to photograph the Shakespearian actor Richard Johnson. They became friends. Johnson was under contract to MGM which was asked to put up some money for the film *King of Kings*, already well into production in Spain. MGM agreed if one of their contract actors, i.e., Richard Johnson, was in the movie. In turn Johnson demanded that David Hurn was used as the still photographer.

It all worked out very well. David became fast friends with the director, Nicholas Ray, and with the publicist, Tom Carlisle, who asked David to stay in Spain for their next movie, *El Cid*, starring Sophia Loren and Charlton Heston. "I was happy to agree," says David. "This was big money compared to the pittance I had been earning for newspaper pictures." So he stayed in Spain for a year and developed a close working relationship with Heston, including a trip to Italy for a costume fitting — the images from which were widely published in fashion magazines, which paid even greater amounts of money. It seemed a good idea to explore this new field. But fashion photographers need a portfolio, preferably using top talent, because David believes that a fashion photographer is only as good as his models. The trick would be to shoot pictures of top models without having to pay enormous fees. This is where Charlton Heston, perhaps unwittingly, could help. He had offered David the use of his New York apartment.

Once ensconced, David called the leading model agencies, dropped the hint that he was a guest of Charlton Heston and that he needed to make test shots of their best models in Heston's apartment. No problem. With these images in hand David called on the legendary Alexander Liebermann, art director of *Vogue*, and received an assignment. Back in London, David called on *Harper's*, told the art director that he had worked for *Vogue* in New York but preferred

Harper's. His fashion assignments began, not only for *Harper's* but also for the most prestigious *Jardin des Modes* — which led to being in Paris for the collections and the chance meeting with Alita.

In turn, the fashion work led directly to lucrative advertising assignments, for corporations such as Aqua Scutum, Austin Reed, Morley and the like. In addition, the movie credits acquired in Spain led to many other assignments on motion pictures, especially those directed by the now (in)famous Ken Russell or those on which Tom Carlisle was the publicist — including all the early James Bond movies which starred Sean Connery — or those in which his friends were the stars, such as Jane Fonda. David's pictures of Fonda in her revealing space outfit for *Barbarella* were published on the front covers of over 100 magazines world-wide.

All this frenetic activity of the early 1960s served to increase not only David's fame, but also his fortune. Lucrative assignments in fashion and advertising led to a lavish lifestyle (including an Aston Martin) and served to finance personal projects. He kept the two aspects of his work widely separated — commercial photography in color, personal projects in black and white. The latter were always the more important. If it seems that there would not be enough time for both commercial and personal work it should be remembered that fashion/advertising is so highly paid that a relatively few days' shooting can subsidize many days of personal freedom. David reckons that during this three- to four-year period he actually shot a maximum of 80 days in the fashion/advertising field.

SUBCULTURES

The coffee-bar scene was also the genesis for many of the ideas with which David's persona as a photographer will always be associated. Most of his commercial work was published without credit, so it was these black-and-white personal projects which were raising his stature among fellow photographers. Today, these projects would collectively be called essays on alternative lifestyles or subcultures. Early in this period David teamed up with the writer Irwin Shaw, and later with the journalist/author Nell Dunne, later to win critical fame for her novel *Poor Cow.* Their first idea was to explore the world of models, who were just becoming known as personalities and celebrities in their own right, and this seemed a natural extension of David's forays into fashion, as well as the fact that many of these models were habituees of the coffee-bar scene. During this project they heard about a model who specialized in taking off her clothes for a living, an unusual and rather radical notion in the early 1960s. This led into another essay on other women who stripped professionally, *A Bit of Flesh.*

One of the choreographers in a strip club was a homosexual and he became the focus for another essay on gays and transvestites. One of David's most famous images of this period depicts two lesbians in the act of lovemaking. From some of these individuals he was introduced to the London drug scene, then in the infancy of what would become the 'swinging sixties.' Hurn states: "We were all very naive about the subculture in those days; it really was below the threshold of daily awareness. So my pictures were seen as rather radical and shocking, even eccentric." It should also be noted that prior to the 60s there would not have been any market for this type of essay,

except perhaps a single image reproduced in a newspaper. Now the color supplements, weekly magazines issued by the major newspapers, were beginning to appear, and they offered a whole new vehicle for the photographer working on sets of pictures on a specific theme.

By the mid-60s David Hurn had amassed an impressive body of work — in news and politics, fashion, advertising and, most significantly, in reportage essays on a variety of sub-culture topics.

For the past ten years David Hurn had worked incessantly for the world's picture press — on assignment and, increasingly, on stories of his own instigation. Quickly the Hurn photo persona emerged: the quiet chronicler of the endearing, eccentric foibles of ordinary people caught up in the panoply of life's pleasures, obsessions and terrors. When not specifically commissioned by one of the top picture periodicals, his favorite activity was to drive his Volkswagen van, equipped for sleeping, to a strange town, scan the local newspaper for current events, and invite himself to participate in whatever activity was going on — from flower shows to MG car owners' ball, from pop concerts to classes in ballroom dancing, from darts contests in the local pub to open days at stately homes. This is still a major component of David Hurn's photographic life and the source of many of his most memorable pictures.

MAGNUM PHOTOS

All this frenetic activity of the early 60s served to establish his reputation as one of Britain's premier photographers. In 1967, he was awarded the highest accolade for reportage work: he was invited to join the prestigious photographic cooperative, Magnum Photos Inc. Magnum had been formed in 1947 by Henri Cartier-Bresson, Robert Capa, David 'Chim' Seymour and George Rodger as an exclusive agency, owned and operated by the photographers themselves, so they could work on serious, humanitarian projects without loss of control to publishers. Membership would be by unanimous decision of all Magnum photographers. In a sense, Magnum was — and remains — an elitist club of the world's top photojournalists. Certainly, David's invitation to join was a major milestone in his photographic life.

How this occurred also fits the pattern of chance which David would admit has played such a major role in his career: "My whole life has been a succession of bizarre coincidences." This one took place in Trafalgar Square where David was shooting pictures. He was noticed by another photographer, Sergio Larraín, a Magnum photographer based in Chile. Larraín could see that this youngster was shooting pictures correctly and invited him for coffee. "This idea fascinates me," says David; "the idea that a few seconds of watching a photographer in action can tell you his/her status in the medium. And it's true. If you watch a photographer of merit working an event he/she does not look like an amateur ... " After Larraín had seen David's work, he suggested that the young photographer should link up with John Hillelson, a London picture agent who just happened to distribute Magnum's images in Britain.

David is quick to give Hillelson a great deal of credit for his future career. "He was a major, major influence in my life. He acted as my advisor, editor and critic, but more crucial in many ways was that he expanded my horizons.

Up to then I had been blinkered in my scope, publishing primarily in the British press. Hillelson opened up the world and my images began appearing in overseas journals such as *Paris Match* (France) and *Stern* (Germany). In addition through Hillelson I began to meet all the Magnum members. So I already was linked to Magnum long before I was asked to join, in that I knew the photographers personally and was already being represented by their agent." David Hurn became an associate member of Magnum Photos in 1965 and a full member in 1967.

PERSONAL CONTACT

It is at this point in his career that I first met David Hurn. In early 1967, as the young editor of *Creative Camera*, I was anxious to meet such a renowned British photographer, and I asked if I could interview him. I had no idea, of course, that a seemingly casual request would change my life so markedly. As I listened to him answer my questions, it is no exaggeration to say that a sort of epiphany occurred. In his clarity of thinking, his direct approach to the medium, and his forceful utterances, I recognized a perfect template for my own, much hazier and unformed, opinions and attitudes. It was after the interview was concluded that I asked if I could come back and show him my own photographs — with the result that opened this introduction.

Yes, his quick dismissal of my images was disturbing and hurtful, but not as much as you might expect. I think that deep down, I knew what he said was true: I would not make a successful photojournalist. Subsequently we talked about what my role in the medium could and should be, and whatever I did thereafter I felt David's presence and guidance within me. He was my silent partner in editorial decision-making, first at *Creative Camera* and then at *Album*, in organizing lectures for young photographers, in preparing exhibitions, in writing articles for journals other than my own, in hustling to gain acceptance for photography within the tradition-bound arts establishment.

My visits to his Porchester Court apartment were growing in frequency — eventually I moved in, editing *Album* from his own office. These were heady times. David Hurn's home was the charged space where photographers from all over the world gathered to discuss images and ideas over umpteen cups of tea. Frequent visitors were Patrick Ward, Leonard Freed, Don McCullin, Erich Hartmann, Charles Harbutt, Elliott Erwitt, Ian Berry, and then Josef Koudelka who also found a home with David on his escape from Czechoslovakia after the Russian invasion. Many are the times when I had to step over his sleeping body to reach my desk. I remember those days with gratitude and fondness, and could write endlessly about these encounters and conversations. But the danger of digression must be avoided, as this introduction is about David himself.

By 1972 major changes, for both of us, were in the air. *Album* had folded and I decided to move to the University of New Mexico to study with Beaumont Newhall and Van Deren Coke, both of whom I knew well and respected from their previous visits to England. David's life was also undergoing a catharsis. He was becoming increasingly dissatisfied with his commercial career and knew that he needed to jolt his personal work back on track, and find a fresh way to make meaningful contributions to Britain's growing awareness of the medium.

WALES

His decision was to move back to Wales for one year, live simply and cheaply out of his camper and shoot pictures of Wales and the Welsh for a book project. He intended to return to London; he merely sublet his apartment, keeping one room for occasional visits.

Again, chance was to veer him in a different direction. During his Welsh rambles he met an administrator of a college and the conversation turned towards the ideal course for a young photographer. David was intrigued. He spent more and more time planning this fictional (or so he supposed) ideal program, even to the extent of designing the perfect darkrooms. The aspect of this mental exercise which most captivated him, however, was: What is it that all the top professionals have in common? And can this be taught? "I saw a pattern in how all the most respected photographers approached their work," says David, "and I believed that these basic principles could be passed on to aspiring youngsters. Although this seemed logical and self-evident to me, I later learned that the whole course was unique." Once Gwent College saw David's proposal he was asked to implement it. He agreed — for two years at the most. He was instigator and director of the program for 15 years.

The School of Documentary Photography, located within Gwent College of Higher Education at Newport in South Wales, was a major success, becoming the most respected course of its kind in the world. David Hurn's talent for organization, clarity of thinking and seeing, and professionalism were now channeled to his students, many of whom have become major figures in the medium.

Meanwhile he was also active in the burgeoning support for photography by The Arts Council of Great Britain, serving on its photography committee and arts panels for many years. He says: "The Arts Council, through the leadership of its director, Barry Lane, raised the profile of fine photography in Britain and gave much encouragement to young photographers, but we also made mistakes. In my opinion it was a mistake to finance photo-galleries — it looked as if photography could not compete in the existing gallery world and that it was therefore necessary to create our own ghetto galleries."

David Hurn was now helping to shape a national attitude towards photography through those establishment bodies, which had spurned the medium only a few years earlier.

His photographs were also achieving recognition by institutions and philanthropic industries and he became the recipient of many awards, including the Welsh Arts Council (1971); Kodak Bursary (1975); the UK/US Bicentennial Fellowship (1979-80), which David spent with me in Arizona; Imperial War Museum Arts Award (1987-88); and many others, including his first monograph: *David Hurn: Photographs 1956-1976*, published by The Arts Council of Great Britain, with an introduction by Sir Tom Hopkinson, the legendary editor of *Picture Post* during its glory years in the 40s.

From 1972 to 1990, David Hurn was one of the sturdiest pillars of the British photographic edifice. He was a full-time college administrator/teacher, an advisor to various councils and committees, a frequent guest lecturer and conductor of workshops, and he still managed

some way, some how, to snatch time to continue his own photography, and prepare exhibitions of personal work. But it was becoming increasingly difficult to juggle all these balls and sooner or later some of them had to be dropped.

BACK TO PHOTOGRAPHY

In 1990 David made a decision. Here's a quotation from a letter he sent to me at the time (22 March 1990):

Dear Bill:

Well my world is about to make the big change. The path to malnutrition. I have decided to give up full-time teaching.

The decision is more from the heart than the head. When I add up possible income and match it against what I get now, the equation never balances. The problem is that I have no desire to be shot at, no desire to sit at the end of a car phone hoping to do three running jobs a day, no desire to photograph the prime minister's cats, in fact no desire to do what I don't want to do.

However, one day I was speculating on how I would like to look back on life and I decided I wanted to feel that I was a photographer rather than a teacher. As simple as that.

It might be that many others will always remember me as a teacher and that won't worry me, I am sure that I will become more and more proud of the achievements of the course as time passes. We

have had a mass of really good students and I am sure I will be constantly reminded of them. Teaching was fun, worthwhile and even sometimes thought provoking, however, it has not really changed my views on anything. Photography is still, to me, mum "snapping" the baby and showing the result to grandma ...

At the time of writing (January 1995) it has been five years since David Hurn severed all links with a regular commitment. He may be poorer financially but he is richer in time. Time to do what he wants to do, and what he does best: take pictures. "When I began teaching it seemed as though I would have plenty of time for my own work, but as the course became more and more successful so the administrative chores became increasingly time-consuming. Also, the ethos of education was changing. At first I had a free hand to apply what worked; later I spent most of my time arguing with administrators who knew nothing about the course or the field. Then came the moment when I suddenly realized that I had been a teacher as long as I had been a photographer, so thereafter if someone asked what I did I would have to reply 'I'm a teacher' not 'I'm a photographer.' That frightened me. I knew I had stayed too long!"

This fact was emphasized when David called on the picture editors with new story ideas: "Perhaps I thought the photo-world would shout 'Whoopee! David Hurn is back!' but the reality was that I was talking to 25-year-olds who had never heard of Magnum, let alone David Hurn. And when I proposed major essays they laughed in my face and told me they never commissioned stories of more than

two or three images, maximum. Times had changed and I was a dinosaur. Actually this cold reception was good for me. I had to rethink my whole approach and I decided to concentrate on major essays of my own choosing, without consideration of the end result." His saleable work would come 'out the side' of these major projects. For example while shooting the two-year project on sculpture he was aware that people were eating their lunches in a variety of places — and this led to a *Lunchbreak* set of pictures for a color supplement which ran across 13 pages plus the front cover and, says David, "helped pay the bills for my own work."

In recent years he has completed, continued and begun a multitude of personal projects including a rephotographic survey of Eugene Atgét's images of sculpture at Versailles; a series which he calls *Documentary Pictures of Romantic Places and Romantic Pictures of Documentary Places*; a large project which attempts to answer the question 'What is sculpture?'; and people posing for other people's cameras. What is intriguing about these projects is that they examine some of the most fundamental problems of the medium itself rather than satisfy a glib need to know what something or someone looks like.

But the point I want to make here is that David Hurn has never curbed his curiosity — not only about the human condition but also about photography itself. He is still prodding, poking the medium in his desire to tease it into giving up its reluctant secrets. This is never-ending. For example, a new series of images of the Welsh landscape demanded, thought David, a contemplative large-format approach. So he

sought out Mark Klett, a landscape photographer whom he much admires, flew 6,000 miles (from Wales to Arizona) and followed him around for days, watching his every move, determined to master a new method of working by learning from a superlative craftsman and artist.

This obsession to get it right, to do it as well as it can be done or not at all, is typical of David Hurn's approach to everything, life as well as art.

THE PERSON

This brief narrative account of David Hurn's career serves the purpose, hopefully, of establishing his photographic credentials as a guide to photographers. As David would say to others: "Learn from the best; the second-raters have nothing to offer." If this book was merely about the craft of photography, then I would stop this introduction right here. But it is not. For David, photography is inextricably linked with life; the photographer is not invisibly behind the camera but projecting a life-attitude through the lens to create an interference pattern with the image. Who he is, what he believes, not only becomes important to know intellectually, but also becomes revealed emotionally and visibly through a body of work.

He has written: "It is the purpose of life that each of us strives to become actually what he or she is potentially. Each photographer, then, should be obsessed with stretching towards that goal through an understanding of others and the world we inhabit. When that happens, the results, like photographs, are really the expressions of the life of the maker."

So it is relevant to ask: Who is David Hurn, the person who permeates the title "photographer?"

Acknowledging that mere words are laughingly inadequate to convey the complexities of a personality, I will nevertheless attempt a verbal snapshot of the person who is your guide …

Let us say you are at an event which David Hurn is photographing: the chances are that you would not notice him. He tends, chameleon-like, to blend in with whatever type of person is present, whether high-society wedding guest or working-class picnicker. He is not posing, pushing people around, creating a pocket of activity; he is discreet, one of everyone, a silent insider. But someone nudges you and says: that's David Hurn, the photographer. So you introduce yourself, and find that he is immediately effusive, perhaps overly so, with the ready smile and enthusiasm of the congenitally shy. That might surprise you, but it is true. For all his world and worldly experiences David Hurn is a shy person, like many photographers of people. This seeming weakness he has turned into a strength. He likes people and through the camera can both connect with them and remain hidden behind the instrument.

Encouraged by his initial warmth you find him an easy person to talk to, because he is genuinely interested in what you have to say, until you wonder if you are distracting him, preventing him from shooting pictures. Unlike most photographers, however, David enjoys company while photographing, as if the conversation is an additional shield to his activities — because, although you do not know it, he has never been distracted for one moment from potential images. Suddenly you find yourself talking to air; David has seen a picture and left you in mid-sentence.

There's a single mindedness about David that can be intimidating to those who have no obsession of their own.

In our fictional first encounter, you ask David if he would join you for a pub lunch after the event, and he is happy to agree. Then you will notice several small but telling details: he is punctual, he doesn't drink alcohol (and never has), he doesn't smoke (and never has), and he has little regard for what's on the menu. David will eat almost anything and enjoy whatever is available; although he is partial to fine cuisine, some of our best mealtimes together have been greasy fish and chips eaten off the packaging.

After the meal you finally start probing the deeper aspects of his personality (probably over endless, endless cups of tea) and quickly find the affable, humorous, empathic outer surface hides an inner core of adamantine conviction. Ask his opinion on anything — politics, religion, sex — and you will receive a brutally direct response. Obviously he has thought, carefully and deeply, about these issues and is now sure of his foundations. You now feel a clash between his personable warmth and chilly Puritanism. This is intimidating for those who are not inner directed, who have not continually assessed their behavior and attitudes and reconciled their individuality with the possible disapproval of others. David will assert his principles, as forcefully and as clearly as possible, in the face of disagreement. For the majority, people of principle are frightening.

David Hurn's principles are rooted in an old-fashioned — or at least unfashionable — belief in the goodness and oneness of the human race, which in this era of casual callousness places him to the far left of the political center, but right in the middle of the working people among whom he most enjoys to interact and photograph.

David Hurn can be rigid, uncompromising, infuriatingly opinionated, intense, single-mindedly obsessive and, at the same time, unfailingly generous, full of warmth and laughter, and a lover of life in all its facets.

It is no surprise that his photographs reflect his life attitude: persistence, hard work, stripped-to-the-bone simplicity with a smile at the edges and an enchantment with ordinary, daily lives.

And it is no surprise that his admonitions to photographers carry the same message: think clearly, act sensibly, commit yourself to caring and work hard in order to discover joy. Then give the images back to the world from which they were taken. He has written:

"In previous ages the word 'art' was used to cover all forms of human skill. The Greeks believed that these skills were given by the gods to man for the purpose of improving the condition of life. In a real sense, photography has fulfilled the Greek ideal of art; it should not only improve the photographer, but also improve the world."

SOME DEFINITIONS

The Naming of Cats is a difficult matter,
It isn't just one of your holiday games;
At first you may think I'm as mad as a hatter
When I tell you a cat must have three different names.

T. S. Eliot,
The Naming of Cats

Bill Jay: *My first editor, an abrasive ex-newspaperman called Alex Surgenor, had an obsessive mantra which he would hurl at young journalists whenever a new story idea was proposed: "If you would discourse with me, first define your terms!" He was right. So, let us begin this discourse with an attempt to name the cat … What do you call yourself?*

David Hurn: I'm a photographer, obviously. My chosen tool for understanding life, and communicating the results of this search to others, is the camera. But I know what you mean. The term "photographer" covers such a broad spectrum of activities that it is not specific, and therefore useful, enough to act as verbal shorthand. Just what type of photographer are we talking about?

My guess is that most viewers of your images will assume they are in the tradition of photojournalism, in that they are taken in real-life situations with a straight, or unmanipulated, approach.

The word "photojournalism" also implies that the subject of the picture is a topical news event, accompanied by words, published in the mass media, usually with the intent to right a social wrong. In this sense, I am not a photojournalist. I no longer cover current events, I work independently of a journalist, I am not interested in bland records of social ills, and my prints are often intended for exhibition, not publication.

But it is true that much of your work is reproduced in periodicals where it reaches a wide audience. In that context, therefore, it would seem to perform as the visual equivalent of words on a page and could be defined as photography-journalism.

Even if that were true, I would still have objections to being called a photojournalist, because the term has gained unfortunate connotations, like the word

"politician!" I mean, what professions should be the most honorable and attract the most idealistic, altruistic people? Politics and journalism. The politician should eschew personal aggrandizement in order to better serve the country; the journalist, in order to stand for integrity, rooting out hypocrisy, corruption and lies. What could be more noble, honorable professions? In practice, of course, both professions are reviled. And the journalist is invariably linked to tabloid sensationalism, distorted information, news as the lowest common denominator of entertainment. No, I don't want to be associated with such a tacky job.

More specifically, the photojournalist is too often associated with a foot-in-the-door, camera-in-the-face, aggression, without much knowledge or concern about the subject or how the image will be used or any regard for issues of ethics or aesthetics. Is that fair?

Not always. The best of this type of work, say by Don McCullin, Abbas, Ian Berry, or James Nachtwey, transcends that characterization. Those individuals, and many more like them, have made it a point to understand their subjects, about which they care deeply — and they also care deeply about the pictures. They are justly famous because not only are the images of publishable subject matter but also because their pictures rise above obvious recording. Single pictures can be taken out of the original context and displayed, perhaps in a gallery, as images of lasting emotional and aesthetic power. But because there are exceptions, these do not invalidate my point that the term 'photojournalist' has unsavory connotations.

Another problem with the word seems to be that when these fine photographers are represented in galleries it is often with the images which are not their best or best known work, so confirming that the field is less artistic.

That's true, too. Once any photographer reaches some notoriety or fame, the art establishment shuffles through all the garbage looking for saleable vintage junk. And every photographer produces rubbish. The art world doesn't do that to painters or sculptures, at least to the same extent.

This point reminds me of a story about Henri Cartier-Bresson, who was telling a group of young photographers about the difference between photojournalism and fine-art photography. He said that the artist Harry Callahan and himself worked in identical ways — enthusiasm for subject, careful planning, working the situation through many, many images, etc. — but the big difference was that he could publish his seconds, the less than the best, whereas Callahan could only use one picture from the set, on a gallery wall.

I agree. The working method of the photographer, whether the end result is publication or a gallery, is identical. But I would add a note of caution to the use of the word "seconds." This could imply to photographers that seconds are bad pictures, which is not so. The seconds are the links between the great pictures and are essential in any published set of photographs. Look at the journalistic assignments of Walker Evans for *Fortune* magazine or the justly renowned essays by W. Eugene Smith for *Life*. Always the fine images are linked together with lesser images and are necessary for pace and rhythm in the layout.

In these contexts the truly beautiful pictures are not reduced by their juxtaposition with seconds. The problem occurs when galleries market the seconds, apart from the original contexts, as the very best single images by a photographer.

By the way, if the term "photojournalist" was used as Cartier-Bresson described it, the keeping of a photographic *journal*, then it would be an appropriate name and I would be happy to adopt it. But it is not.

If we are having trouble with the term "photojournalist," I can foresee just as many problems with the term "documentary photographer."

Right. This is particularly true today when a document implies unbiased, non-judgmental, objective, factual evidence. And, of course, no photograph — at least no photograph that I am likely to make — even comes close to this notion.

I wonder how this arose... that documentary photographs are associated with objectivity? The term has a strange history in the medium, as you know. In the 19th century the documentary photographer did not exist; the implication, though, would be that the photographer produced copies of manuscripts, plans and such-like flat documents. It was not until the 1930s that John Grierson introduced the term "documentary film" — but his definition was unabashedly linked to a subjective, opinionated point of view: propaganda. That was reasonable, as the root of documentary is the verb docere, to teach. Odd that once the word was transferred to still photography it meant the opposite: objective evidence.

The fact remains that if I were called, or called myself, a documentary photographer it would imply, to most people in this day and age, that I was taking pictures of some objective truth — which I am not. And even if I knew what I meant, in any conversation I would have that bizarre feeling that the other person is presuming or talking about something entirely different. So it's not very helpful.

I understand that you are not a documentary photographer in the sense that most people would understand the term, so what is the relationship between your observations of reality and that problematic word truth?

It is tenuous at best. If truth implies factual accuracy and objectivity, then the connection is completely severed. The only factually correct aspect of photography is that it shows what something looked like — under a very particular set of circumstances. But that is not the same as the underlying truth of the event or situation. As to objectivity, it does not exist. In my own photography I have two fundamental controls: where I stand and when I press the button. Both are very subjective choices so the end result, the picture, is bound to be equally subjective.

My concession to objectivity is more of an attempt towards honesty in relation to the subject matter. This is only an attempt.

What do you mean by honesty?

I cannot define it, but that does not concern me very much because its opposite is clear. In other words when I am taking a picture I know in my heart if I am being dishonest to the subject, if I am not being true to my instincts or feelings. This is different from factually correct. I may, for example, later find that my initial reaction was misguided. That happens. But I can still be honest and sincere at the time. You just have to do the best you can. I never claim my photographs reveal some definitive truth. I claim that this is what I saw and felt about the subject at the time the pictures were made. That's all that any photographer can claim. I do not know any great photographer who would presume otherwise.

Even though the term "documentary photography" poses problems you used it for your course, The School of Documentary Photography. Why?

In the absence of an ideal term, "documentary photography" came the closest to describing a type of photography which would be broadly recognized in Britain. It served not so much to describe what we did but, more importantly, to define what we did not do! In other words, documentary photography was not fashion, not advertising, not cutting up images and producing manipulated art, and so on. Anything left was loosely subsumed under the category "documentary." And that included a broad range of photographic activities, from hard paparazzi-style news work to architectural, landscape, or botanical photography to images intended for a gallery wall, if they were made in an unset-up, straight style. In other words, the title of the school served to cut down the number of applications. During interviews we could further define our needs. This was not a contentious issue for the students. They understood what we were intending. The problem occurred in our academic environment, by anti-everything bureaucrats who, with typical verbal diarrhea, incessantly hammered on us for an exact definition of "documentary." It was so irritating because it was such a waste of time. I would respond: our students understand what we mean, so why is it so difficult for you to understand?

For various reasons you are not a photojournalist and you are hesitant to call yourself a documentary photographer because your images are subjective and personal. Fair enough. Is there a term which you prefer above others?

Yes. I think of myself as a reportage photographer. I like the word. It implies a personal account of an observed event with connotations of subjectivity but honesty. It is eye-witness photography.

Or, I witness… with the emphasis on the first person singular!

Words, words, words. Are we finished with definitions yet?

Not quite. I think it is important to clear up one further point before we talk about the practice of photography, and that is the idea of narrative which is implied by the terms picture-story or photo-essay. And I know you would agree that images are not linear explanations or narratives in the same sense that words are stories.

That's true, but I cannot think of a good term which defines a series or sequence of pictures where the whole, the group, is stronger, visually and emotionally, than any of the individual images. I agree that a set of pictures is never narrative in the usual meaning of the word. For this reason, I think the word *essay* is slightly better than *story*.

When I talk about the picture or photographic essay I mean a group of images in which each picture is supporting and strengthening all the others; not that the sequencing of the pictures can be read like a string of words.

Take Robert Frank's *The Americans*, for example. It is a superb photographic essay — but it is not narrative in the visual sense. The sequencing of the pictures might have a visual logic but that is very different from a narrative/idea logic …

Might have a visual logic? You sound unconvinced! Yet thousands of words have been written by critics on the logic of the pictures' sequencing.

I know. I have just read a paragraph by one of the best, and certainly one of the most readable critics, A. D. Coleman, praising Frank's process of "redacting his imagery into a spare, taut, book-length sequence." I must say, I find such assertions fascinating. But just how much was this sequencing and picture-selection due to Frank's choices and how much due to Robert Delpire, the book's editor/publisher? And if they were mainly Delpire's does that make any difference? I will certainly try to discuss this with Allan next time we meet.

Similarly I once read a very clever and convincing rationale for the sequencing of the pictures in Bill Brandt's book *The English at Home*; but just how much of this analysis is an after-the-fact reading applied by a smart critic, compared to Brandt's original intent?

It reminds me that I was around Josef Koudelka on a daily basis when he was preparing the layouts for his superb book, *Gypsies*. Over the period of a few weeks he rearranged roughly the same pictures into a dozen or more different sequences. I would be very, very surprised if the final one was any better than most of the others. Also, I'm sure Delpire, who prepared and designed *Gypsies*, had a great influence. Koudelka is a very smart man; he would listen to the advice of someone he respects.

Anyway, my point is that care must be taken in the arrangement of the individual units in any grouping of photographs, but I suspect that beyond a certain point it does not matter as much as critics would lead us to believe. And *whatever* the sequencing, the result is not story-telling.

In spite of your suspicion of definitions, I do think this has been an important preface. As Herbert Spenser said: "How often misused words generate misleading thoughts." Now that we are all thinking clearly, let's move on.

SELECTING A SUBJECT

They said, "You have a blue guitar,
You do not play things as they are."
The man replied, "Things as they are
Are changed upon the blue guitar."

Wallace Stevens,
The Man with The Blue Guitar

Bill Jay: *When we were discussing some definitions you remarked that photography's core characteristic was to show what something looked like. I think this is an important point because many photographers seem fascinated with the medium yet have no idea what to photograph.*

David Hurn: That's true. The fundamental issue is one of emphasis: you are not a photographer because you are interested in photography.

Explain what you mean.

Many people are interested in photography in some nebulous way; they might be interested in the seemingly glamorous lives of top fashion or war photographers; or in the acquisition and admiration of beautiful, functional machines, the cameras; or in the arcane ritual of the darkroom processes; or in the persona which they could adopt if only they took pictures like... whoever. But these interests, no matter how personally enjoyable they might be, never lead to the person becoming a photographer. The reason is that photography is only a tool, a vehicle, for expressing or transmitting a passion in something else. It is not the end result. An analogy would be to buy a car for its status appeal, for the idea that it will improve your sex-life, for the smell of the new upholstery, for the fascination with its beautiful engineering, and so on. But it is useless unless it actually takes you somewhere.

The destination of photography is to reveal what something or somebody looked like, under a particular set of conditions, at a particular moment in time, and to transmit the result to others.

Right. However, a word of caution should be inserted here. Although what you just said is true, it does not imply merely bland records of anything. Some pictures are obviously more interesting, more beautiful, more inspiring than others, even of the same subject matter. More than that, they are indelibly stamped with the unique style, for want of a better word, of the individuals who made them. So what transforms these simple records into pictures of lasting merit?

How would you answer?

It comes down to the choice of subject. The photographer must have intense curiosity, not just a passing visual interest, in the theme of the pictures. This curiosity leads to intense examination, reading, talking, research and many, many failed attempts over a long period of time.

I'm intrigued by this idea: it seems to me self-evident that in order to photograph with any degree of continuous passion, you must have a fascination for the subject, otherwise you cannot sustain an interest in the act of creation for a long enough period of time in which to make any insightful or original statement about it. And I had to learn this lesson from you. After you had told me in 1967 that my photographs were "boring," as I related in the opening pages, I could stop the struggle to be a photographer-like-other-photographers. It was such a relief. I began shooting anew, with a simple concentration on the subjects which most interested me, with no thought of success, prestige, or reputation, but with a joyous liberation — which continues to this day.

I'm pleased that you raised the issue of your own photographs. I was a bit concerned that we had left the reader with the impression of you being a failed photographer — which was not an encouraging idea for a joint-author of a book on the practical issues of the medium! I was disparaging about your images 30 years ago because they were derivative of the work of others whom you admired. They were not your own. But since then you have been intensely involved with your personal subject matter — particularly portraits of photographers — and produced a huge body of work which not only contains fine single images but also adds up to a major historical record.

Let us make the point clear: when the subject takes precedence, you not only start the journey towards a personal style but also you discover the sheer joy of visually responding to the world. It solves a lot of doubts, clears away all confusion.

The reason for a young photographer's confusion is that most teachers, classes, workshops, books, whatever, imply that how the picture is made, what techniques were employed, why it looks different and artistic, is more important than the subject matter. Yet the photographer is, primarily, a subject-selector. Much as it might offend the artistically inclined, the history of photography is primarily the history of the subject matter.

So a photographer's first decision is *what* to photograph. Your curiosity, fascination and enthusiasm for this subject can be communicated to others through the pictures you take of it.

This reminds me … Ralph Steiner, the late, great photographer, would occasionally write me a funny, provocative letter after he had read one of my published articles. He would end with the words: "But you still have not told me in which direction to point the camera — and this is what matters." And he is right. So let's get down to brass tacks, as the British would say, and give specific advice on the choice of subject matter.

Garden gnomes!

Only kidding. My guess is that giving specific advice on what to photograph would not be appreciated even if it was possible — and it's not, because how could I know what excites the curiosity of others?

True, but we can talk about the basic principles of subject selection.

The first thing to do is carry a notebook and during quiet times or as the thought occurs to you, compile a list of anything that really interests you. In other words, write a list of subjects which fascinate you without regard to photography. What could inflame your passion and curiosity over a long period of time? At that stage, make the list without any regard for photography. Be as specific as possible. After you have exhausted the list, you begin to cut it down by asking yourself these questions:

Is it visual? You can safely eliminate such fascinating (to you) topics as existential philosophy or the Old Testament or the existence of intelligent life on other planets.

Is it practical? You can cut out topics which are difficult or impossible to photograph at your convenience on a regular basis. For example, if I were a photographer of limited means living in, say, Denver, I would have to eliminate the topic of Japanese pagodas, at least as far as photography is concerned. Or I would cut out an interest in famous film stars — the subject must be not only practical but continually accessible.

Is it a subject about which I know enough? Eliminate those subjects about which you are ignorant, at least until you have conducted a good deal of research into the topic. For example, you are not contributing anything to the issue of urban poverty by wandering back streets and snatching pictures of derelicts in doorways. That's exploitation, not exploration.

Is it interesting to others? This is a tricky one, but it is worth asking yourself: if you have several remaining topics all of which are equally fascinating, which one is interesting to others? This is tricky only in that it ignores the issue of your intended audience, which might be a small, specialized one, and the issue of pandering to public appeal.

I would like to interject a note on this last point. I know, as a professional lecturer, that it is difficult to transmit information (in say, my own passion for topographical photographers of the wet-plate period) to a bored, disinterested audience. I must engage and hold the audience's attention before the content can flow. On the other hand, I am not a professional entertainer. So there is a very fine line between pandering to popular appeal and a respectful consideration of viewers'/listeners' attention-span or interest in the content. It is what I call a respect for the bum-factor — just how much is the audience aware of the seats on which it is sitting? You are talking about a similar fine line between your interest and the interest of the viewer.

Yes, if all of the final selections interest you equally, it does not seem like a compromise to select the topic which others are more interested in viewing. The state of being human dictates that some things are more interesting to look at than others.

But we could discuss this gray area *ad nauseum* and thereby forget the essential point: the subject matter you select must: a) fire your enthusiasm and curiosity for at least the length of time it will take to produce a meaningful body of work; b) lend itself to images, as opposed to words and; c) remain continuously accessible so that you can return time and again to the same topic whenever you wish or have time.

I want to add a few remarks about your exhortation: be as specific as possible. It is invariably true that a list of interests will include topics which are far too broad to be useful. In my seminars on research and writing I have to spend an inordinate amount of time on the student's choice of topics for precisely this reason. Every time a student proposes a topic for research it is a book-length theme not an article. The difficulty is to encourage a small, specific do-able project. He/she will propose "Victorian portraiture"; I suggest Lewis Carroll's images of Alice. He/she will propose "The Photo Secession"; I suggest the members' use of a glass ball as a motif. He/she will propose "Latin American photography"; I suggest the digital imagery of Pedro Meyer. These are not specific cases but merely examples of the need to cut down a vast, general topic into manageable segments.

It is the same when selecting topics for a visual essay. When I say "be as specific as possible," I mean: take on a project which is containable and can be completed within a reasonable period of time. Also, the more precise the topic, the easier it is to conduct research. Now let me give some general examples. If your list contains an interest such as *education*, make it "My Life as a Student at so-and-so campus"; "Flowers" becomes "Plants That Relate to Architecture"; "Portraits" is reduced to "Cleveland Sculptors In Their Studios." Anyway, the point is taken...

For many photographers this list-making might seem an overly pragmatic, too coldly clinical approach to subject matter. I'm sure many will be thinking that it destroys the pleasure of the visual adventure.

Maybe. But the fact remains that it works, and just wandering around looking for pictures, hoping that something will pop up and announce itself, does not work. Sorry about that, photographers, if it offends your fantasy of how a photographer behaves!

All I can tell people is that for forty years I have talked to many of the best photographers in the world, in various areas of the medium, and there is a common denominator among all their approaches to the taking of pictures: they are enthusiastic and knowledgeable about their subject matter and they plan ahead of the actual shooting.

We will return to this idea of planning ahead a little later. But I can foresee another objection to this issue by an aspiring photographer. That is, all the talk about emphasizing subject matter indicates we are only advocating a strict, straight recording of faces and places. It is important that we state, categorically, that we are talking about starting points, for all photographers. In fact the idea is not restrictive at all; it offers more scope for a continuing evolution of complexity and, hence, a greater latitude for personal interpretation.

That's true. The narrower and more clearly defined the subject matter at the start, the more quickly identified is the "direction in which to aim the camera," as Steiner said, and the more pictures are taken. The more the shooting, the greater the enthusiasm and knowledge for the subject. The greater your knowledge, the more you want to do it justice and this increases the scope and depth of the pictures. So the process feeds on itself.

There is an analogy which I like to use: When I landscaped my garden I needed to plant trees. I could have obtained an instant tree by collecting an assortment of trunks, branches, twigs and leaves and assembling the bits. But the tree would be dead; it would never grow into something else. So the starting point was a sapling which, by careful nurturing, and a good deal of patience, will grow into a tree, often into a form which could not have been predicted. It seems to me that it is the same with a body of work, of any merit, in photography. The greatest scope for deep-rooted, organic growth begins with the simplest of premises: the direct visual encounter with a selected subject.

As you know, I find it useful to answer problematic questions by turning the issue upside-down, such as the issue of honesty, that can be solved to my satisfaction by knowing what is dishonest when taking pictures. It is the same here. What is the alternative to an emphasis on subject matter? It is a frantic grasping for instant gratification which all too often leads to works displaying visual pyrotechnics but of dubious depth and resonance. Photographers become pressured into a search for different-ness, a quest for newness which usually means an unusual technique: your dead-tree syndrome.

There is another problem here. If the images are not rooted in "the thing itself," to use Edward Weston's term, then the photographer has not learned anything about the real world. He/she can only justify the images by reference to self: "This is how I felt." Before long, this leads to incredibly convoluted psychoanalysis in a futile effort to justify the most banal, superficial work.

How I shudder at the interminable, self-indulgent, often incomprehensible photo-critiques I have been obliged to attend. My response to all those words about self is that the photographers are inviting judgment on themselves as people, not photographers, and that's foolish. It seems an extraordinary presumption that every photographer has a depth of character which demands

revelation! And if the self is shallow, narrow, superficial and inconsequential, then, they are admitting, so will be the resultant photographs.

And there are no standards. What I mean is there can never be any objective benchmarks against which to measure the success or failure of these images. If a person says, "This is how I feel," you cannot respond, "No, you do not feel that way."

Mind you, I have no objection to anyone using photography for personal therapy. That seems a valid use of the medium. I guess what we are saying is that these images will have an audience of only one, the person who made them. Rarely will they have any resonance or value to a larger audience.

Most photographers would do the world a favor by diminishing, not augmenting, the role of self and, as much as possible, emphasizing subject alone. I'm not being facetious. Such photographers would be members of an august group — the majority of photographers throughout the medium's history, most of whom remain unknown as personalities. However, the emphasis today is on a cult of personality and individualism, and I presume that the majority of photographers who encounter these words are anxious to assert self, as well as subject. Do you have any words of encouragement?

In today's art-photography environment any one who asserts the prime importance of subject matter will automatically produce distinctive, different images!

Now I am being facetious. The fact is that all photographs, even of the most prosaic records of things, are subjective. They are made as a result of various decisions arising out of the mind of an individual. So inevitably that self will intrude on the picture-making process. It would be impossible to keep it out. But it is not the primary aim of the images. A unique style, which is what we are talking about, is the by-product of visual exploration, not its goal. Personal vision comes only from not aiming at it. Over a long period of time and through many, many images, the self re-emerges with even greater strength than if it were the end-product. Ironically, by starting with self, it is missed; ignore it, and it becomes evident.

Like walking back to my cabin in the forest by starlight: you can only see the direction, the track, by not looking directly at it. Or back to my tree analogy: the living entity, the visible thing we call a tree, is only sustained by the root system which is not only out of sight but must be kept underground for the sake of the growth and to prevent the tree blowing down during the next wind of change. I know the analogy is being stretched to breaking point, but I was struggling to link the idea of a clear, intense examination of "the thing itself" with the hidden self, the photographer's life, which sustains it.

Bad example, but I know what you mean. I think the answer is very simple — and is intimately connected with the choice of subject matter. No two people will make the same list, or edit it down in the same way, or for the same reasons. Therefore, by the simple act of choosing a topic to explore photographically, you are asserting self. Then, the more this topic is a concentration of your whole focus, the more you become a mini-expert

in it, the more chance there is that it will spread and deepen into an intrinsic part of your total consciousness.

I once watched a television interview with a great violinist. The interviewer asked him to describe a typical day. The musician said he read scores over breakfast, then composed music in the morning, thought about music during a walk, practiced the violin in the afternoon, played in a concert in the evening, met with musician friends to play together, then went to bed dreaming of the violin. The interviewer was aghast: it seemed such a narrow life. "Yes," said the violinist, "initially my life was becoming narrower and narrower in focus. But then something extraordinary happened. It is as though my music passed through a tiny hole in an hour-glass and it has since become broader and broader. Now my music is making connections with every aspect of life."

In a real sense photographers are photographers one hundred percent of the time. Everything connects. On my way to see you I read on the plane four essays by Michel de Montaigne and constantly saw links between his ideas and photography — even though the essays were written in the late 1500s. I always find it fascinating to see a movie, for example, with photographers whom I respect. Inevitably, their later conversations reveal all sorts of useful observations that they have made, sucked out of the plot, dialogue, acting, camera angles, pacing, whatever, which can be applied to their own work. Every event becomes grist to the photographic mill. And scores of learning events are occurring daily. All this new insight is fed back to the subject of the pictures, so it is no wonder that who a photographer is becomes revealed through what he/she photographs.

The ultimate aim is an oscillation between self and subject with the images being a physical manifestation of this supercharged interface between the spirit and the world.

Yes. But let us take a reality check. What you said is right but it sounds profound. The reality is much simpler, and can be explained with an everyday occurrence. Take a mother on a beach watching her child build sand castles. She suddenly sees an expression which tugs at her heart-strings. Without thought, she dips into the picnic basket, aims the camera, and presses the button. The moment has been captured — and will be treasured for the rest of her life.

Eighty-five percent of all the ingredients of photography are encompassed by this simple act. The mother has an intimate knowledge of her subject; she is the expert on that child. She is enthusiastic in her love of the subject. There is no thought of self or creativity, although both are intimately present. The snap was made without concern for technique. These are the ingredients which should be present in the acts of all photographers, no matter how sophisticated, yet they are the very ones which are too often ignored.

Mum, the photographer, has no interest in fancy tricks or style or special visual effects. Her job is simply to record the moment, and the place. Both the taker and potential viewers expect to recognize who is in the picture and the circumstances of it. When put into the family album the photograph might have a simple, factual caption to help: "Brighton Beach, first pair of shorts on Jimmy." The mother/photographer unconsciously uses the

probability factor. It is probable that the connection between the visual appearance of the event and the resulting photograph will be identifiable with the relationship between herself and her subject. And it is probable that the end product, the photograph, will convey to the viewer enough of the same message to make the exercise useful, satisfying and even meritorious. It will not give total accuracy of the message, not all of the facts, not all the feelings, but enough to make the exercise worthwhile.

Now the trick is how to convert the 85 percent to 100 percent; how to transform a record of the event into a satisfying picture; how to make the particular, universal…

And that will be a major topic of conversation in a separate section. But before we leave this theme of subject matter, I wanted to hear your thoughts on an issue which occurred to me when you were describing the mother on the beach. She not only had an interest in the subject of the picture, which we agreed was essential, but, more than that, a love of the subject, the child.

I see where you are taking that thought. It is the difference between a thought and feeling, an intellectual idea and an emotional attachment. I think a photographer can make a wonderful set of pictures of a topic which is purely intellectually or visually based without having a deep, abiding love for the subject matter. Let's think of some examples.

Most of the time, unless we knew the photographer very well, it would be impossible to know the depth of emotion compared with intellectual knowledge. But I would guess Francis Frith was not particularly in love with the pyramids of Egypt during his trips between 1856 and 1860. He certainly knew a great deal about them. Did Eugene Atgét love the sculptures at Versailles? I do not know, but they do not give that impression to me, although they are wonderful images. On the other hand, I do think he loved the back alleys and shop-fronts and cobble-stoned byways of old Paris which were to be destroyed — and I think it showed.

But then I could be projecting my own feelings for the subject matter onto the images.

I was thinking of Alfred Stieglitz's cloud pictures because we know he said that they are the equivalents of emotional states. I read what he says but to me they remain pictures of clouds. His portraits and nudes of his wife, Georgia O'Keeffe, seem so much more intimate and full of love. And there are Harold Edgerton's experiments with his invention, the strobe or electronic flash. They were made to show off the abilities of a new piece of technology, dispassionately perhaps. Yet they are visual marvels. The one depicting the flight of a bullet through an apple is one of my favorite images in the whole history of the medium.

Personally, I have always had trouble with this concept, which is why I raised it. There's an implication that emotion and intellect are adversarial, that one precludes the other, that the rational is antithetical to emotion. Yet my own experience is that opposites always work in conjunction. If I am intellectually stimulated by a topic it is not long before I am emotional about it; if I am emotional about something or someone, then I want to know more about the subject of my affection. So perhaps this is a false issue. The word "interest" especially accompanied by an adjective like "intense" or "enthusiastic" covers the spectrum about a subject, from cold rationality to hot passion.

The more I think about it, the more I am inclined to believe that individual pictures can be very important even when rationally, intellectually made but the bodies of work, the lifetime achievements of a photographer, which impress me the most are those based in love as well as knowledge.

I remember the first time I saw a large number of photographs by Stephen Dalton of insects in flight. Immediately I could sense that Dalton loved these little beasties! He was also extremely knowledgeable about them, a fact which is underlined by his learned texts accompanying the images. In addition, it was evident that he carefully planned his photographs in advance, even to the extent of designing and building specialized equipment to achieve the end results. So it seems to me that his work employs all the elements we have been discussing.

A more familiar name, because he appears in the major history textbooks, would be Lewis Hine, and I am thinking particularly of his work for the Child Labor Committee in the first decades of this century. His pictures of children working as slave labor in dangerous environments ooze passion and outrage, yet he had to plan the taking of the images with cool detachment, even employing subterfuge, otherwise the owners of the mill or mine would not have given him access. He did not seem to mind that his pictures were badly reproduced in poor halftones because the subject matter was more important than his reputation as an artist. As far as I know, he never received a single exhibition of his work while he was alive. Now, of course, his prints are taken out of context, overmatted and, rightly, exhibited as art.

I could go on — and on. The point is that all photographers of stature whom I admire seem to share this fundamental characteristic: a deep and long-lasting respect and love for the subject matter.

The best pictures, for me, are those which go straight into the heart and the blood, and take some time to reach the brain.

I agree.

SHOOTING THE SINGLE PICTURE

You see, but you do not observe.

Sherlock Holmes to Dr. Watson,
Arthur Conan Doyle

Bill Jay: *Reviewing the position so far: the photographer has selected a subject in which he/she has a strong involvement, about which a good deal has been learned from research, reading, writing, talking, and which is continually accessible. Now the photographer is anxious to begin shooting. What's the plan?*

David Hurn: This is the fun part. The photographer must always keep in mind that there is a purpose to the picture. That purpose is to reveal the chosen aspect of the subject matter, to clarify its essence — and to accomplish this goal through a visually interesting picture.

Which sounds pretty nebulous …

But it is not. There are two fundamental elements in all picture-taking: where to stand and when to release the shutter. These are the two basic controls at the photographer's command — position and timing — all others are extensions, peripheral ones, compared to them. So photography is very simple, which is not to say easy.

Let's take each control and discuss its ramifications. First, position …

Where you stand in order to take the picture determines the visual clarity of the subject, whatever it might be. How much time is at your disposal to find the exact position will be determined by the movement of the subject. Obviously, a static subject will give you more time to locate the right position than one which involves several moving elements. But the principle is the same.

Take Harry Callahan's photograph Cape Cod which is a very simple image depicting a volleyball net on an expanse of empty beach, with the sea in the background. Nothing could be more static. I am sure that, to many people, the impression is that Callahan was wandering around, saw the net, shot a picture and moved on. It looks as if the total amount of time spent on the picture was a few seconds. In reality Callahan probably spent a long time exploring this particular image, as we can see from the 11 frames on his contact sheet. We know that he kept shooting from very slightly different angles and positions; he was not content with first impressions.

I do believe that very often the difference between an average photographer and a really fine photographer is this willingness to admit doubt, that he/she is not at all certain that he/she has "got it." The fine photographer says, in effect: "Well, that's a pretty good effort but I am willing to admit that many little subtleties of camera position, which I cannot pre-see, might make the difference between an adequate image and a good one."

And don't forget that this is a person who is photographing a static subject with a medium-format camera, yet is willing to try all sorts of subtle permutations to increase the success rate. This is very, very different from the notion of shooting a lot of pictures and hoping to find something worth printing after looking at the contact sheets.

What you are saying is that even with a static subject containing very few elements there are many small changes of distance and angle which could make big differences in the effectiveness of the final picture. How much more complex, then, is the subject which is in motion!

That's right — but the principle is exactly the same. It is just much more difficult to achieve. The principle is that photography is a matter of tiny details.

I like the phrase which was commonly used at the beginning of the medium's history: photographs of merit were judged by their "meticulous exactitude." Although it was used to denote sharpness it is equally applicable in terms of small variations in camera position, or timing.

Yes, and as soon as we move from a static subject to a moving one, the element of when to take the picture is inextricably linked with where to stand. The two elements are no longer separate acts but are part of the same decision-making process.

There's a wonderfully symbolic image by Leonard Freed depicting a prisoner's hand reaching through the bars of his jail cell. In this case, the position was pretty much fixed and the only moving element was the hand gestures. Freed shot a whole roll of film on this simple subject. It seems to me that this was essential, because he was in a unique, privileged location and could not reshoot at will and he wanted to make sure that he captured the best possible picture of the situation. It was not a matter of banging out 36 images in the hope that one will survive: it was an awareness of small incidents — a tension in the wrist, a straightening of a finger, a bunched fist — and it was not possible, under the circumstances, to determine which tiny change would produce the strongest visual impact.

In this case the *where* was pre-determined but the *when* was the changing factor.

But in both cases you have emphasized the taking of multiple exposures in order to increase the chances that small variations are available in the contact sheets for later selection. Although we are still talking about shooting single pictures, as an end result, the method of achieving the one good image is to take many frames.

In all cases the pressing of the button is a reasonably continuous process, because you never know if the next fraction of a second is going to reveal an even more significant, poignant, visually stronger image than the previous one.

So let's take perhaps the most complex situation … say, a beach. Here you have an infinite number of choices of where to stand, with a continuum of distances from long shots to close-ups, throughout 360-degree angles of view, and everyone is in motion. What strategy would you use for making picture decisions in these circumstances?

This is where your list is essential. You are at the beach, or wherever, for a purpose, and that theme has been subdivided into potential picture-making categories. There is usually no point in just rambling around a beach looking for pictures in general, because the visual overload precludes seeing anything. So the first essential is to know, in some specific way, what you are looking for.

For example, one of your beach categories might be "couples showing affection." In this case, you are more alert and aware of potential subjects, to the exclusion of others. This is a way to manage the overwhelming number of choices. So, you suddenly see a young man moving purposefully towards his girlfriend and the possibility is that he is going to kiss her. You move in to a reasonable position and take a picture; you move a fraction to the left in order to avoid that tangle of legs behind their profiles; shoot another picture; you notice the edges of the picture are too complex, so a movement forward; another picture — and nothing. He was just reaching for the sandwiches!

Most of the time the picture is not there, but it might be, and you would have been in the right position at the right time if the image had materialized. What is even more certain is that you would not have obtained the picture if you relied on a single grab shot.

You are talking about pregnant moments, potentially interesting situations that might give birth to a picture, and shooting multiple frames throughout the action, with slight adjustments to clarify the main part of the subject.

There is a lot of luck in capturing a significant picture, but the good photographers cut down the waste and make the shot far more likely. When I am looking for pictures I instinctively sense situations that might contain good shots. I then latch on to the situation and start shooting. Sometimes that action will build up into a climax in about six to ten shots, and then drop away. At other times, the action will start to build up… but then stop at nothing. So you have to forget that scene and latch on to another pregnant situation. A typical example: I saw a group of young people while shooting pictures at Henley Regatta. I was probably first drawn to them because of their obvious relationship to each other and their pleasing geometrical arrangement. The girl was fingering a ring, and possibly newly

engaged. I shot a picture. Suddenly the fiancé held the ring finger. I shot another picture. Then he kissed the ring. I shot another picture. He was still kissing it, giving me enough time to move slightly and improve the geometry of the situation in front of me, and shoot yet another picture. That's it. He drops the finger, the action is over.

I want to stick with this method of working for a while for two reasons. The first is that throughout all my years in academia looking at images by young photographers it is evident that no one has explained to them this way of shooting and the second reason is that throughout all my years of looking at images by fine photographers it is evident that they all work in essentially the same way. There is this huge chasm between what good photographers actually do and what young photographers think they do.

All we can emphasize is that the great photographers, in all areas of the medium, work in remarkably similar ways. And if this is true, and I believe it is, then there is a lesson to be learned from this consistency.

Look at the contact sheets by the best photographers and one fact is evident: they have committed themselves to a position where they can see most clearly what is taking place; that position might vary through a succession of images, especially if the subject is moving; then frames build up to a crescendo where a gesture, expression, or arrangement of shapes signal that the image is captured — or the sequence abruptly ends because the event has collapsed.

The contact sheets show a rapid, staccato series of images with slight variations, then end. Or, infrequently, the series builds up to a climax before falling apart. What fascinates me is that you can see the mind of the photographer at work when looking at contact sheets.

Exactly. Through the contact images you can read the intent of the photographer. You can nearly always tell what he/she is attempting to achieve; you think: "So that's what the photographer thought might happen. It didn't work out but if it had occurred then he/she would have been in the right position to capture it." Then someone who knows little about this way of working will see a single image, say in a book or at an exhibition, and think: that was a lucky shot! And the response is: well, yes, it was lucky because even after you have invested all this concentration, it is a gift that all the elements come together in a perfect union; but, then again, the best photographers are adept at getting luck on their side and being in a position to capture the luck when it happens.

At an exhibition of photographs someone button-holed Edward Steichen and asked: "If you were to take out of this show all the "accidents," how many [pictures] would you have left?" "Not many, perhaps," answered Steichen, "but have you thought how many great accidents have been made by great photographers?"

I think he must have been quoting me!

I think we should interject that this method of working is not the sole prerogative of the reportage photographer. I was intrigued to discover at the Center for Creative Photography, in the Ansel

Adams archives, that his famous image, Moon and Half Dome, Yosemite, was one of 10 almost identical exposures which he made at the time.

True. Many large-format photographers work in a remarkably similar manner to reportage photographers: Walker Evans, for example. If you look at his proof prints you see that he did not adamantly decide: this is where the camera must be. He often made subtle changes in viewpoint of the same building facade. There are very few photographers I admire who do not work in this way, and that includes image-makers who are seemingly very different from the reportage type.

I know when I am shooting portraits that the primary concern is viewpoint, or the angle at which the person must be photographed in order to isolate the most important part of the picture, the face. Nothing kills an otherwise interesting shot more quickly than a messy background which clashes with or confuses the profile. Once that is clear, I can concentrate on other elements in the background — and it is then that I become aware of the frame, the edges of the picture. Ideally I want an image in which a) the main area is revealed with maximum clarity b) all elements within the frame are in harmonious relationships c) all these internal patterns are in harmony with the frame itself and d) the moment of exposure is at a significant fraction of a second in which something surprising is taking place. Is that asking too much?

It is fine to ask — if you don't expect to receive! But that is the driving, obsessional force behind photography, the fact that although the elements are simple to state they are extremely difficult to integrate. Aiming for your goal is worthwhile as long as you realize it is a constant effort, rarely to be achieved. If you reached those heights more than a few times, you would be a great photographer.

Seriously, it is almost impossible to juggle more than a few variables — many of which have lives of their own and are moving in independent, unpredictable ways — and keep them in mind during the briefest of moments when you are composing a picture. All you can hope to do is keep an eye on the main element (it helps if it is static) and then organize two or three sub-elements by position and timing, shooting frame after frame. All the other elements depend on the luck of timing. It is wonderful if they all happen to fall into place together. The chances are that they will not. But we keep trying.

Let us take a couple of your own images where more than a couple of elements all fuse into an harmonious arrangement. I would like you to talk us through your actions and thought processes during the shooting. For example, Promenade at Tenby, where a dog is asleep in the foreground, a cannon is pointing out to sea, a woman in a hat is walking away …

This is a good example because the image looks complex but was, in fact, quite simple.

When I arrived at the scene I immediately saw certain elements: the cannon, the people asleep, the dog. I quickly maneuvered myself into a position where these three basic elements were all isolated from each other but together formed a strong diagonal. That was *where* taken care of. I shot a picture but knew it was not right. It was a bit too static for my taste. So I moved away, to the other side of the hill, saw a couple of other possible

images, then returned to the original scene. Now, more was happening. The basic elements were still in place but people were walking up the hill behind the cannon's muzzle, other figures were walking along the skyline to the left, someone was sitting down, a boy was playing on the cannon itself, and so on. I found my original position, altered it slightly to include the seated figure, and now I am watching all the other moving people as they interact and change the visual pattern. Now I am shooting small bursts of pictures because I cannot be sure that the flux of movement will be arrested at exactly the right moment. Only on the contact sheet can I see the one frame where all the elements work together.

In this case the key foreground elements were not moving so I had the luxury of concentrating on the sub-elements.

Then let us take an example in which every element is moving: Miners' Week, Barry Island, where the foreground depicts a father and child playing at the sea edge but the background beach is a patchwork quilt of moving elements.

Let me first say that this image is part of a major series on the changing culture of Wales. A section of the Wales project is on coal mining. A subsection of coal mining is the one time of year when all the mines close together for the annual summer holiday. I was at the beach for a specific purpose: to depict a miner at play with his child during his vacation at the seaside. Everyone on that beach was a miner or a member of a miner's family. So I already knew what I was looking for. That's important.

Having seen this miner with his daughter I was struck by the warm relationship between them. My initial reaction was to choose an angle of approach, to move into position from which I could clearly see the relationship — isolated from the confusing background, lit effectively so that the faces were revealed, and forming an interesting shape in and of itself. The next decision was: how far should I move towards or away from them? Too close and I would eliminate the idea that they were playing on a crowded beach; too far away and they would lose dominance and become just another small element. So the correct distance was quite precise.

Then I looked for another element in the background which I would call a "significant other"; some small object or person or something, anything, which had visual appeal. I am now watching the relationship between father and daughter, and at the same time keeping an eye on the background element. I shoot pictures when a gesture, expression or whatever in the foreground is balanced by a shape in the background. I can barely control these two factors, especially if the secondary element is moving. I might have to shift six inches sideways or back and forth, shooting several frames in order to keep the elements in balance.

What I cannot do is keep track of every element in the background. My eye is making rapid flips across all these details to check on the overall pattern but basically I'm centered on the foreground/background element relationship. I have to see the contact sheet to know what has happened. I know that the foreground is fine because that is what I have

concentrated on but my choice of image to enlarge will depend on the geometry or pattern of the general background, which I cannot predict.

A painter can compose the main elements and then add the significant details in precisely the right places. In photography, you cannot do that. You are hoping, almost by instinct, that the small details which make or break the picture are going to be in the right positions.

How many frames would you shoot of such a situation?

It depends. Half a dozen frames would be the average, on a complex scene such as the beach. Paradoxically, the more static the scene the more images I tend to shoot. When there is only one moving element, say the hand of the person you are photographing, it is very, very difficult to decide which gesture, which position of the wrist or fingers is going to be the most significant.

And now we have traced a pretty circle — back to the idea that the more static the picture, the more emphasis will be placed on details. So here is another issue: While you have been talking, an incessant little voice in the back of my head has been prodding me to raise the, to some, contentious ideas implied by "good design," "geometry," "composition." These notions of harmony and beauty are antithetical to many contemporary attitudes to street photography, especially in academia. Let's clear the air.

I hope we have not implied that there are rules of good design or that we are advocating composition based on drawing lines over the image! Nor am I very interested in design where the sole purpose of the picture is to demonstrate the cleverness of the photographer in finding patterns in peeling paint or shadow shapes. Pictures which are solely about pattern-making are pretty boring.

However, I do believe that good design is essential when its purpose is the clear projection of the subject matter, that is, when design is the vehicle not the destination. If you like, function produces form. When you have most clearly revealed the essence of the subject, the chances are you have produced a good design, at least in my definition of the term. The design, though, has come second; it has followed the first priority, to reveal the subject.

The issue of whether or not the image *should* be carefully composed is self-evident as far as I'm concerned. If the image is well designed, you want to look at it; if it is poorly structured, you don't care about the image and, hence, the subject. It does not seem reasonable for a photographer to produce an image of a subject which he/she purports to care about, only to reject the viewer because the image is visually unappealing.

Yet that attitude exists. A short while ago I was at an exhibition in a university fine-arts gallery featuring photographs taken of people in blighted urban settings. They were bad pictures, in my opinion. Disorganized, sloppy, lacking clarity and even badly printed. Unfortunately the photographer wanted to know what I thought. I tried to explain that there is a rich history of this

type of social documentation from which we can learn; specifically, how the elements can be clarified in order to produce effective pictures.

His response was interesting. He said he knew about that old stuff but he deliberately created bad pictures in order to reflect the confusion, angst, chaos and violence of the real world. I was then treated to a dose of post-modernism, structuralist theory and the assertion that these prints reflected how he felt "as an artist."

Bad photographers have many excuses! And what I mean by "bad photographers" is that no one is interested in looking at their images. Surely, if the images were visually compelling then more people would want to look at them for longer periods of time and the subject would have a greater chance of revealing itself.

That is true even with a difficult, abstract idea like "chaos." The extraordinary ability of photographers like Ian Berry or Sebastião Selgado is that they could shoot pictures in the same situation alongside many other photographers of lesser ability and not only clearly reveal the chaos but also produce images of power which so impress themselves on your consciousness that they are never forgotten. That's what I would call good design, which is inseparable from good photography.

This reminds me of a conversation I once had with Graham Greene. He said that the most difficult parts of a book to write were the "boring bits." I asked him what he meant by that remark. "Well," he said, "the parts that are full of action are easy to write. But the difficulty comes in the linking sections where nothing happens. The trick is to write them in such a way that the reader is interested in continuing."

Yes, there are some situations where it is more difficult to obtain interesting pictures than in others. But it can be done, with effort, and that's what we should strive for, not making excuses for failures.

Here's another objection to your notion of "good pictures" which I have heard bandied around in academia. The argument unfolds like this: if you take a beautiful image of a subject depicting a social problem then the viewer's reaction will be "what a great photographer," "what a fine picture," and the social message will be lost. The attention is focused on the maker, not the subject.

I do not agree with that idea, which I have heard before. It is the humble artist syndrome: I try not to make good pictures because I want to submerge myself as an individual, an artist, and allow the subject to rise the surface. It is such a stupid argument.

What is indisputable is that the better the picture the more people will look at it over a longer period of time — which means the subject matter will have more resonance whatever the original reason for admiring the image. I have never understood the idea that the picture is "too good"; it is never too good as long as the subject has been clearly revealed. The photographer's aim is to create beautiful pictures, of any and all subject matter.

I agree. What many "artists," especially those who attempt political commentary, tend to forget is that photography is a picture-making medium. If the primary motive of a person is to comment on ideas then a more effective medium would be words. I do not understand how any photographer can justify making bad photographs, even if the goal is some sort of political/social message. And there does seem a corollary at work here: the more politically correct the message, the dumber the picture. Personally I would rather see a beautiful image of any subject than a bad picture of a flavor-of-the-month idea. Just before we had this conversation I was looking at Flora Photographica: Masterpieces of Flower Photography 1835 to the Present compiled by William Ewing. Many of the images are stunningly beautiful and the measure of their beauty is that I now want to learn more about flowers, a subject which has not been particularly interesting to me in the past. So, yes, the subject matter is transmitted by good design, geometry of the picture, beauty, call it what you will. I am sure a book of bad flower photographs would not ignite my interest in plants for the simple reason I would not want to look at them long enough or with enough intensity.

For many people the word beauty is associated with the predictable — pictures previously seen and already in their memory banks, cliché images of sunsets, small furry animals, pin-ups, postcard views, and so on. For me, most great photographs displaying beauty reveal a sensation of strangeness, not predictability, a kind of shock non-recognition inside the familiar. They are the opposite of clichés; they have a quality beyond the visually obvious. But even if it is difficult to define, beauty still lurks behind the scenes. I like the remark of Robert Adams: "The word beauty is unavoidable… it accounts for my decision to photograph… There appeared a quality, beauty seemed the only appropriate word for it, in certain photographs, and I am compelled to live with the vocabulary of this new sight… though over many years [I] still find it embarrassing to use the word beauty, I fear I will be attacked for it, but I still believe in it."

I was about to end this topic with the remark that beauty is so charged as a word that we are not being of much practical help to photographers. But then I remembered we started on the idea by discussing good design which seems a factor in the equation. This thought led Josef Koudelka to take proof prints of near misses, cut out all the elements in the image, and rearrange them — as a guide to the picture he should have taken. Seems a good exercise …

When I look at great photographs of any type there seems to be a common ground: a sense of inevitability. I cannot imagine how the images could have been designed in any other way. They seem complete just as they exist.

Bring us back to earth, David. How much is good design a matter of luck compared to instinct sharpened by experience?

When you are photographing a scene in which all the elements are moving, there is no doubt you are lucky if they all coalesce at the same time into a beautiful picture. You attempt to see everything and release the shutter at the precise moment, but usually the most you can do is be in precisely the right place so that you will get the shot if it happens.

It is also true that a good deal of experience means you are more aware of small elements which can make a big difference, in very practical ways. One of the lessons you learn is that dogs are very useful in backgrounds! For some reason they have a shape which is very distinctive. So if I see, say, a dog leaping for a ball in the background, I would instinctively move this way or that in order to integrate that element with the main subject.

Experience probably teaches the subconscious mind which helps you find the right position, organize the separation of elements, sense the coming together of actions, just a little bit quicker and more efficiently. So, yes, experience obviously helps — which is another reason to shoot lots of pictures. With any luck, one of them will be beautiful!

CREATING CONTACTS

"Look here, upon this picture, and on this."

William Shakespeare,
Hamlet

Bill Jay: *Our hypothetical photographer is now fully involved with his/her chosen subject, has shot several films with the working method you have described, and is now anxious to see the first images — the contact sheets.*

David Hurn: So let us emphasize that this is a vitally important stage, which is why we are giving it a separate section. I will make no excuses for the faint-hearted: the making of a perfect contact sheet from a processed film is essential.

What do you mean by "perfect?"

I mean that it must be as sharp as technically possible (which usually means ensuring flat, even contact between negatives and paper) and correctly exposed and printed. A fuzzy, unclean contact sheet is useless; a correctly made group of contact prints is one of the photographer's most useful tools.

In a perfect world every frame on the film would have received a perfect exposure, all the negatives would have identical densities, and a blanket exposure of the contact paper would reveal every tiny image with maximum clarity. In practice, several frames might be under- or over-exposed and print too dark or light on the contact. These small areas must be shaded, dodged, or burned in so that every image is perfectly printed. How can you judge the merits of the image if you cannot see it?

I know that some readers might think this is a difficult chore — for a print which no one will see. My response is: contact sheets will be seen, by you, and you cannot make intelligent choices about blocked-up or burned-out images. Also, if printing a contact sheet so that each image is correctly exposed is so difficult then you do not have the basic skill to make a final print worth showing to anyone.

I am smiling not at your adamancy but in memory of all the student work that has been thrust upon me. Usually the first encounter is a box of badly printed proofs which tell me very little about what the photographer is attempting, so I ask to see the contact sheets. The funny/sad thing is that there might be a dozen images I can actually see on a contact sheet of 36 frames with all the others indecipherable dark or light rectangles. I am obviously expected to guess at the original images. So let us repeat this fact for extra emphasis: the contact sheet is most important because it is the first time you actually see a picture as opposed to reality — you must be able to see the picture clearly. No ifs, ands or buts.

Examining the contact sheet, it should also be emphasized, is not just for picking the best picture ...

For me, the contact sheet has four main purposes:

1) I shoot a lot of what I call "dear diary" pictures. Those images have no foreseeable use and I never intend to enlarge them. But they act as simple visual records, personal reminders of people met and places visited. I will also shoot a frame of a street sign, to give me the location of other frames on the same roll of film. It's easier than writing down the information in a notebook. One of the photographer's greatest pleasures is to look back at ten-year-old contact sheets. The images provide an open door and total recall to the pleasures (and pains) of the past.

2) The contact sheet is a valuable teacher. The image is now static and there is all the time in the world to make choices. You stand or fall by how critical you are with your own work and by the decisions that are made from a careful analysis of the contact sheet. The emotional involvements with the event at the time of shooting are now in the past. It is time for a cold, critical and objective appraisal of the image itself. Presumably, when a photographer presses the button it is because he believes the image is worthwhile. It rarely is. Why? If the photographer is self-critical he can attempt to analyze the reasons for the gap between expectation and actuality. This is a most effective learning process. The contact sheet reveals how I have been thinking, and how efficiently my instincts have controlled the framing of the subject. If I have trained myself to deal with the small size, it also teaches me by revealing my mistakes without the expense of making enlargements. I can analyze each frame by asking myself such questions as: would the image have been better if I had moved a few feet to the left or right; could I have improved the picture by moving closer or further back; what would have been the result of releasing the shutter a second earlier, or later? Such ruthless self-examination through a contact sheet is one of the best teaching methods.

3) Marking the contact sheet isolates any particular frame in order that the images can be retrieved more quickly. It is a convenient time- and money-saver. I use a different marking system (various colors of pencil) to identify the various uses of the photograph, whether magazine, exhibition print or personal gift. I also write on a large white area on the contact sheet, masked specifically for this purpose, and make notes to myself. These notes not only include a numbering system, and short captions of event, person or location, but also remind me that the picture should be reshot at a later date.

4) Looking at the contact sheets of other photographers' work allows me to understand their methods of working and their thinking processes. I gain an understanding of, and often respect for, their final prints by this analysis. What is amazing to me is that I can see that their working methods are so similar — little sequences which show the photographer stalking the image, as we have already described.

I would like you to expand your remarks about the filing/marking system. Obviously, we are not talking about absolutes here — other photographers will have their own, equally efficient, methods. But I think photographers will be interested in your method if only to emphasize the important principles.

Fair enough. The essential principle of any filing system is that you can retrieve any negative you need, quickly and efficiently.

As I said earlier, I make my contact sheets on 9½ x 12 inch sheets [a standard size in Britain]. I could print all 36 frames on an 8 x 10 inch sheet of paper. However the extra size allows me to contact 120 film on the same size paper. In both cases a broad white space is printed at the top, in which I can write minimal captions, such as date, place, description of event.

But the most important information is a numbering system which, in my case, is organized like this:

The first two letters of my last name attached to the initial letter of my first name (this is necessary in my case as my contact sheets will be filed in Magnum's office and simple initial only might be duplicated by another photographer, with ensuing chaos); year; job or project number (e.g. 001 = family snaps; 002 = Welsh miners etc.); a letter indicating if the images were also shot in color; number of contact sheet, from my first ever to the present, e.g. #9,999. And, of course, the individual frames are already numbered on the negatives.

The contact sheets are stored in ring binders; the negatives, in separate ring binders, have identical matching numbers. So if someone wants negative #17, taken in 1990 on project 003, I can find it with no trouble. Each individual will have a slightly different numbering system but its function will remain the same: efficient retrieval of any specific image, no matter how long ago it was taken. For this reason, there is no point in having an efficient numbering system unless this number is written on the back of every print at the time of enlarging it.

I like the idea of over-size printing paper for contacts, allowing for a caption strip, but surely there is not enough space for the details which are necessary when working professionally.

No, I need a separate data base for detailed captions, containing as much information as necessary, but these too are numbered with the same system. Until recently these captions were also kept in ring binders but now they are in my computer.

Then there are the multi-colored marks on each contact sheet …

Yes, I use several grease-pencils of different colors when marking frames on the contact sheets.

As soon as I see the contacts, I mark any image of interest, for whatever reason, in white.

Then, if at all possible, I like to put aside the contacts for a few weeks. This serves to distance me from the emotion of the picture-taking moment so that I am better able to see the image dispassionately. Too often when we look at our own pictures we remember the excitement of the event, which becomes mixed up with our cool judgment of the results. Then again, if an image was particularly difficult to shoot, we justify it: something so hard to achieve must be worthwhile. For these reasons, I like to show the contacts to a photographer I respect. This person is unaware of my feelings, can cut through the memories and fantasies, and will only see what is actually there, in the image itself. Anyway, the images which I select as being useful for a particular project are marked in yellow.

During these examinations I come across images which are "give-aways." These are prints which I have promised to send to the subjects. I always make it a point to send out prints if I have promised to do so. In fact it is an essential act, for two reasons. First, it would be rude not to keep your word. Second, it makes it difficult for the next photographer to obtain cooperation from the subject if you have broken a promise. So, tell the truth: *no, I cannot send you a print,* or *yes, I will send you a print.* The "give-aways" I mark up in blue.

At a later date I will look for images which will be used in publications and exhibitions, or will be sold as original prints to collectors. These final selections will be marked in red.

I feel sure that a lot of photographers are now thinking about the time involved in making perfect contact prints, creating an elaborate filing system, writing extended captions, color-coding the contact images — and they thought a photographer was continually out there, shooting pictures!

Perhaps all this does sound complex and time-consuming, but, believe me, the time saved in being able to quickly retrieve any given negative, and to know when and under what circumstances it was taken, more than compensate for the initial work involved.

Then again, it is a myth that the photographer is always shooting pictures. I would guess that three-quarters of my time is spent on research, reading and thinking about the project before shooting and analyzing the contacts after shooting. Elliott Erwitt, who is responsible for most of the witticisms that I remember in photography, has asserted that he cannot recall a project that took more than five seconds to shoot! And he's right. Five seconds equals lots of 1/250-second exposures.

I am sure we all know some individuals who wander around with their ever-present cameras and call themselves photographers who do not invest time in preparation or clear thinking — and therefore do not take many pictures. Photography demands a lot of work before and after the actual shooting.

Talking of bad photographers, I have often heard it said that one of their characteristics is that they look at their contacts in order to discover which is the best picture, whereas a good photographer examines each frame on a contact sheet and asks: why is this one not a good picture?

I agree. A good photographer is always striving for the perfect image, knowing that it is rarely, if ever, likely to be achieved. Therefore his/her presumption is that the image is not ideal, so the question becomes: why not? This is what I meant by the contact being a learning experience.

I think this fact has a lot to do with the reluctance of bad photographers to show their contact sheets or proof prints to others, yet I have never seen this reluctance among the best photographers. Indeed, the opposite seems to be the rule. The finest workers urge you to look at contacts and proofs.

I am puzzled by photographers hiding their contacts as though they were secret, private things. I would go further. I already know which images I like, so I would rather show colleagues the bad ones. They might find a good image which I had mistakenly overlooked or rejected. I do not want them to endorse my own choice but to help me discover new images, ideas or directions.

So yes, all the best photographers of my acquaintance share their contacts or proof prints. They have very few secrets from each other, and share ideas and advice on upcoming projects. There is very little competition in the negative sense, even when two photographers are covering the same event. They know that if they are good photographers, the images will be seen very differently; if they are bad photographers then it does not matter.

Back to the issue of looking at contact sheets: I have noticed that when you talk one-on-one to photographers you are more interested in their contact sheets and failures than in their best prints.

For the reason I want other photographers to see my doubtfuls. There is not a great deal of pleasure in only seeing what someone else considers their best pictures. I cannot participate fully in the process or help the person in any meaningful way. In this role of a critic I can best help by first understanding what the photographer was trying to achieve. The contact sheets provide this entry into his/her mind.

I do not want to end these remarks on the contact sheet without reiterating that fine pictures depend on very subtle, small details. Your point about making perfect contact prints so that you

can see these details in each and every frame is well-taken. But the image, even if well-printed, is still tiny. How do you examine the images on contact sheets?

Initially I use a large self-illuminated magnifying glass which sits in its own stand. It is not very powerful but it enables me to see several adjacent images at the same time, so I can make comparisons between similar frames in the sequence. Then I switch to a superior quality high-magnification lupe, in order to see the smallest detail in an individual image.

Then you make proof prints from the selected frames.

Yes. All those images I like are printed on 8 x 10 inch paper. Many photographers prefer making 5 x 7 inch prints but, for me, the larger proofs have several advantages. They are easier to assess when tacked up on the wall (three of the walls in my office are covered in cork for this purpose) and the slight increase in cost is offset by the fact that I can sell them for reproduction if necessary.

I am struck by how many great photographers I have visited who have walls of prints which they are in the process of considering, the ones which have not yet been totally accepted into the best-picture category. Dorothea Lange used to call these her "second-lookers." Diane Arbus tacked these prints all over the wall opposite her bed, so they would be the last things she saw at night and the first things on waking up.

It is important to live with these images to see which ones last. But it is even more important when working on a picture essay, for reproduction or exhibition, so you can see at a glance how the images work alongside each other or in sequence. The pace of the project becomes visible.

And the special requirements of the picture essay is what we will discuss in the next section. Meanwhile, many photographers reading these words will notice that we have not discussed processing and printing — and they might conclude that these procedures are unimportant.

Of course they are important. The second you load a camera with film there is a presumption that you want to end up with a technically good picture. But there are many fine books in print which are devoted to these matters.

So let us concentrate, for a few moments, on what you consider the most important aspects of processing and printing.

The easiest way to end up with a good print is to start with a perfect negative, which means correct exposure, correct development, and perfect cleanliness. If you have achieved these characteristics then it is almost a mechanical certitude that you will (or can) obtain a good print.

Making a negative is a chemical process. The more uniform you make each step in the process, the nearer you will get to consistent results.

Presuming that the initial exposure is correct, then the first link in the chain is the developer. The making up of the developer is in fact important. I have discovered to my cost that the world's water sources are not necessarily chemically the same. I suppose there is a logic in this. Different countries, states and cities put different additives into their water supplies. These will produce different development times in the various places. Rule of thumb: if you are going to be in a new place for some time then do tests.

The next link in the chain is the temperature of the developer. I have discovered that it is difficult to find two thermometers that give identical readings — therefore always use your own. In my case I am so paranoid that I have two matching thermometers, both very expensive ones, that I check against each other before starting a developing session.

The next link is the development time. As I have already hinted, do tests on your combination of developer mixture, using your thermometer and for your given time. As long as you now keep the stop bath and fixer at roughly the same temperature you will get consistent results.

Make sure everything is kept very clean: no dust and always filter liquids. I use doubled-up coffee filters. Everything from then on will be easier.

Or you could send all your exposed films to a processing lab, which is standard for most photographers in your position. So why do you insist on developing your own films?

It is, of course, possible to find a lab that will take care of all the above. I expect the majority of professionals do. In my own case the negative is so important — I find it so difficult to get a picture I enjoy — that the thought of damaging it is more than I could bear, particularly if someone else makes the mistake. I feel I have to take this responsibility so I do it myself. However it's the most boring time of my life.

And then number the negatives and make sure you can find them again!

Having got the negatives, remember that, by definition, they will always have a historical use, so make sure they last. Take care of them and file them in archival storage bags. These cost more but they are very important. Also devise a method of accurate filing. When you have 40,000 negative sheets, each with six strips of negatives, you will realize that putting one back in the incorrect place is the same as putting it into the waste paper basket.

I noticed that you did not recommend any particular brand or manufacturer of chemicals.

Go and see a mixed exhibition of the work of photographers you admire. See if you can instantly notice what film/developer combination they use. If you can't tell the differences then you have proved that it doesn't really matter. I can easily mention five photographers whom I admire who all use different combinations. I have no idea how they came to their own decisions. Probably it was as simple as what brands were stocked by the local shop. The reality is that every manufacturer has spent fortunes on research so they have

probably all got it right! You will have no problems, if you start with the paper instructions in the box and then adjust for your own eccentricities and ways of working.

Any last thoughts on the making of prints?

Remember that it's no use having the world's best lens on your camera and a second-class one on your enlarger. Equipment is as good as the worst component. All the best printers seem to give the best advice. Do the work under the enlarger. Always leave the paper in the print developer for exactly the same time at the same temperature. Sadly — as it is wasteful — do not process too many prints in the same developer. It has a surprisingly short life for the maximum quality of print. If I had my choice I would always have an expert do my prints for me. I would of course supervise until the printer knew my peculiarities. I am a great believer that someone who spends his/her life in the darkroom, and actually likes it, is always going to do a better job than me, who prints almost as a casual event. If I have to print (for cost reasons) I always go in the darkroom for a month at a time — usually the winter — and spend the first week re-learning. Like most things practice makes better, if not perfect. Kelly Kirkpatrick, who prints many of Mark Klett's negatives and is as fine a printer as I know, visited me in Wales for a short time. She generously offered to make a few prints for me, from negatives of a project which was an extension of the time I had spent in Arizona with Mark. She made wonderful prints even though she was working in a strange, unfamiliar darkroom. The frustration for me is that I cannot match them even though I carefully watched every stage of the process.

THE PICTURE ESSAY

Memory demands an image.

Bertrand Russell

Bill Jay: *So far we have emphasized single pictures but most of the archetypal images in photography have been extracted from the multi-image projects of which they were intrinsic and essential elements. We tend to forget this fact, that photographers of merit tend to work on projects involving many pictures, not just on single masterpieces.*

David Hurn: Also, we tend to forget that many of these images were initially taken on professional assignments where the number of selected images depended on the purpose of the pictures, such as a magazine story or a commissioned exhibition. So the intended audience, and the method used to reach that audience, are important factors when planning a major project.

Photographers should not put pictures in a box under their beds and be the only ones to see them. If they put film in their cameras it presupposes that they want to record what they see and show somebody else. Photography is about communication.

Once the photographer has selected a project theme which can sustain his/her enthusiasm for a considerable length of time, the first question to be answered is: what is the purpose?

Yes. Too many projects dribble on for years because the photographer has not cut it down to the essentials. They do not ask: "Why am I doing this? What interests me? Where, and how, will it be used." It is no good spending seven weeks shooting pictures for your local newspaper if it is only going to use one photograph.

Too many people waste time taking unusable photographs. If they cannot be used, you are back to the box of prints under the bed. If I am doing one picture on a housing estate and I decide that the most frightening thing is that the place is empty. I do not wander around photographing kids in the playground or the local school. I concentrate on the one important picture.

I meet so many photographers who wish to work in some documentary way with no idea of how to put together a story in pictures. A passionate social concern does not automatically make you a good photographer.

It is true for artist-photographers who have no idea how to put together an exhibition in pictures, or a monograph, or a portfolio in an art/photography journal. The same principles apply.

The second question, once the purpose of the project has been determined, is: how many pictures are required? Most projects are capable of being divided into many, many different picture-headings, so you have to decide on the number required for the final purpose. It might be only one image or perhaps seven prints for a magazine layout; 40 for a one-person exhibition; 120 for a major book, or whatever.

Once you know the number of images which will complete the essay, you must divide your topic or theme into that many picture-headings. List them, and alongside each heading jot down the words: "overall/establishment picture," "medium distance/relationship picture," and "close-up picture." These notes act as a shooting script and remind you that the final essay must have pace, that is, you avoid visual boredom by changing the rhythm of the photographs within the set. Obviously, you do not preconceive the essay but you must be aware of the basic structure in advance of shooting. The aim is to take images which become your memory of the event.

Explain what you mean with a simple example.

Ask somebody who has been to a protest march or demonstration what they remember about the event and they might reply: "There were about 6,000 people there, most of them very quiet, many of them were middle class and a lot of them were women with kids. Most were reasonably smartly dressed." When you look at their contacts you see five people in unusual clothes and a punch-up that lasted all of three minutes during the three-and-a-half-hour march. The pictures do not relate to the photographer's memory of the event. Too often, the photographer looks for the visually strong picture rather than covering what actually happens.

Why? One excuse is that this is what papers want to publish. Perhaps more accurate is that most photographers do not have the ability to record the event as it is. They take the easy option, the visual cliché.

The important point is to plan, in order to provide a basic frame-work to which you can return whenever you are stuck. It does not mean that you must rigidly adhere to every picture-heading if the reality is different from your preconceptions.

No, but you cut down the preconceptions by exhaustive research on the subject. That's another reason why it is important to become a mini-expert on the topic before the picture-taking stage. And not all research is cerebral; it includes visual research and research by experience. For example, if the subject is an event which is repeated, you should first visit it without a camera or at least plan not to seriously shoot pictures, but make visual impressions of the key elements.

For example, say you decide to create a picture essay on a particular club: you start by going to the club, sitting down and spending an evening there, looking, absorbing, being a part of the atmosphere. When you leave, write down in a notebook 12 headings or however many images you need to complete the project. You might jot down "loneliness" (because some members seem to spend the whole time alone) or "people in conversation" or "competition at the pool table" or "heavy drinkers" or "flirting" or whatever stuck in your mind as an impression. Of course, this list will depend to a considerable extent on the personality of the photographer.

This is your memory of the event.

Then you go back to the club and attempt to photograph those headings. This means that if there is a club with a stripper in the corner you do not spend nine weeks out of ten photographing the stripper and one week photographing the more difficult headings. You may photograph all of the 12 headings on the first night. Then look at your contacts and when you get a photograph which fits one of the headings you tick it off and do not photograph that any more. You then concentrate on the other 11 headings. The first picture is almost certainly going to be the stripper because the simplest thing in the world is to photograph some person taking off his/her clothes.

After a couple of nights, you have completed all the easy, pictorial photographs and can then concentrate on the equally important, but more taxing, aspects of the project.

The list which you wrote down after the first visit tells you that these are just as important as the stripper. For the first time you spend more time on the difficult photographs. When you complete the list of 12 headings, you know you have finished the project. You have the story. It is bound to work in a personal way, because that is how you remember it. That does not mean that you cannot branch out from your chosen 12, or six or 20 headings. If something exciting happens in the corner, which is not on the list, of course you take pictures. But it does mean that every time you get stuck you have a framework to go back to, and — most important — it does mean that *you know when you have completed the story.*

With this method you do not spend five weeks shooting pictures desperately hoping that the story will somehow make sense. You do not end up with 80 percent of one situation and 20 percent covering the other dozen or so equally important happenings.

The next step is to spread out the images or, in your case, tack them up to a wall, and see if there is enough visual variety within the set.

Yes. You might have too many images taken from the same distance. So you choose the best image from that group and re-shoot the weaker ones as close-ups or long-shots or in any manner which imparts a sense of pace to the final set.

So you now have a finished essay with the number of images demanded by the end result, which have covered the key elements of the topic, which have visual variety and which accurately

reflect your memory of the event or theme. This last point is important because it reprises the idea of honesty. You have fairly represented the subject matter, as much as that is possible from a subjective point of view.

My best pictures are the ones that say: "That's what I remember the place to be like." It is very rare that they accomplish this goal. It is difficult to match your photographs with your memory. But that is what photography is all about.

I agree. It seems so fundamental, yet rarely discussed for some reason. But do not let us leave the photographer with the idea that this method of planning an essay or the importance of memory only apply to journalistic endeavors. They are equally good principles for all types of photography. My own interest, as you know, is taking portraits of photographers whom I meet during my travels. These are not intended for any publication or exhibition but the same basics of planning, awareness of pacing and, most important of all, a sense of memory are essential ingredients. Certainly when I am looking through the contacts I am more interested in the images which most strongly conjure up the individual's words, the tone of voice, the personality, than I am concerned with the best picture. It is the most potent memory-joggers which are the most valuable.

I do not expect young photographers to take the best pictures in the world. I do expect them to have exciting ideas, well thought out, that they know how to finish and put together into a coherent essay. Learn to get the basic things right, then worry about all the other brilliant ideas that you have for doing things in different ways. Do not hide behind not being able to do it the simple way by pretending that you are above such things.

It is important to go and do the essay, finish it, try to get it published or exhibited and realize it is there for historical use at a later date. Then get on and do the next set of pictures.

And learn from the mistakes and failures of the just-completed one, which, as you have already emphasized, is the most effective learning process. Which brings up an issue which is also important but rarely discussed: photography is a medium of quantity as well as quality. What I mean by this is that you cannot be a photographer by aspiring to be one, or learning everything there is to be known about photography. Photographers produce photographs. And many of them. Like every other skill, photography is learned by continuous and dedicated practice.

That's true. But the practice must be directed. In other words, it is not a learning process to wander around banging off frames of film for the sheer fun of shooting pictures. You learn by concentrating on a subject, planning the actual shooting and critically evaluating the results.

That's true, too. I still want to make the point that enthusiasm for the subject leads to a lot of exposed frames. I will now tell an anecdote which involves you …

You had just arrived in Arizona for a year's stay and I took you to the local photography dealer. You asked if he stocked brand-x film. Not knowing who you were, he said: "Yes sir," and placed

a single cassette on the counter. You said: "Fine, I'll take 1,000 of those!" He was taken aback, to put it mildly. Now I know for a fact, because you were living with me at the time, that every frame had been exposed within the year. That equals an average of 100 frames per day, seven days a week. So don't tell me quantity is not important.

No, I won't. But the quantity is not important for its own sake; it must be focused on specific subjects in the ways that I have described. Also, I am worried about setting targets in terms of "how many frames you should be shooting." There are no rules. You will take far fewer images if you are working with medium- or large-format cameras. That's obvious.

To some extent, your quantity will also depend on the types of subject and even your own personality. An extreme case, of course, was Garry Winogrand who was an obsessive, compulsive shooter, leaving behind at his death 3,000 exposed but still undeveloped films. But even here there was a structure beneath the chaotic surface. I stayed with Winogrand in Venice Beach a couple of years before his death. We went shooting together along the beach front. He was using, as always, his Leica fitted with a 28mm lens and firing it like a machine-gun. Over coffee he talked about a book project he had been offered. I asked what he would be shooting. He said he would extract something from his files as he always worked on many projects at the same time — he thought he might have enough on airports as he spent a lot of time in them. I was fascinated to find so much structure in the working method of someone whom we are told was so unstructured. But perhaps photographers talk in a more open manner to other photographers they trust?

He was so very aggressive whereas many photographers of people, such as yourself, tend towards shyness. Even if you do not think this issue of quantity can be, well, quantified, it would be helpful to provide a clue to your own way of working, if only to show that good photographs happen rarely.

As a general guide I would guess that for a seven-picture essay I would shoot 20 to 30 cassettes of 36-exposure 35mm film. A single, exhibition-quality image probably occurs every, say, 100 films. For what it is worth.

Now back to shyness … We have emphasized that the photographer must have a sustained curiosity about the subject. This poses no problems for the shy photographer if the subject in which he/she is curious happens to be, say, the intricate forms of plants. However, it would seem that a major problem has been created if the shy person is particularly and intensely curious about the lives of other people, especially strangers.

This issue arises far more frequently than others might suspect. It makes sense, however, that shy people are curious about other lives because they are always aware of their fear and anxious to overcome it by reaching out to strangers. When fear stops them, they are even more sensitive about their shyness.

I believe the camera is about solutions, not problems. The camera allows me to interact with strangers because it provides two services: one, it provides a shield, something to hide

behind, so that when I look through the viewfinder I am interacting with an image, not real people; two, it provides an excuse for being in that situation, if someone approached me and asked: "What are you doing?"

For example, if I walked into a ballroom dance competition out of sheer curiosity but without a camera, undoubtedly I would feel uncomfortable. I would not know what was going on: I would not know anyone there. I would be afraid that someone would approach me and, in all innocent disregard for my shyness, ask what I was doing. Quite possibly my reaction would be inadequacy, a feeling of being out of place and isolated so I might become defensive and leave, thinking: "how stupid it all is." But what I am actually admitting is that I have an unreasonable fear of strangers. All this changes with the camera in my hand.

It gives me both an invisibility cloak and an excuse for intruding into other lives. "I'm a photographer" is an open-sesame to places and people I would otherwise avoid. In reality, of course, you soon discover by experience that if you are genuinely interested in what's going on, then people become extremely friendly. One of the easiest ways to overcome shyness is to be a photographer.

We, as human beings, tend to deride and sneer at those things which are outside our everyday experience. I guess it is the ancient tribal law: those outside our own clan, who behave differently, are the enemy. My hunch is that reportage photographers become very tolerant — even humanistic — because of their broad range of experiences with people of different interest, cultures, social backgrounds and political viewpoints. Photographic familiarity does not breed contempt, but forbearance.

It does not have to be based in photography. I think you could achieve this level of understanding without a camera. It would depend on your personality. The mere fact that you entered a different activity or life-style, displayed genuine non-judgmental curiosity about it, listened with sympathy — even if you made it clear that your own opinions would not be swayed — then my guess is that you would quickly find the participants a fascinating group. My shyness, however, would preclude me from such participation.

The camera is my entrance-ticket. It is also my way of clarifying (for myself) what is going on. Finally, it is a way of passing on this new-found experience to others.

I suspect many, many reportage photographers are shy personality types. It would be an interesting research project to discover if people-photographers make up a higher percentage of shy persons than occur in the general population. I can think of many heavily-funded projects which are less interesting! By the way, there is a very funny book called The Shy Photographer *…*

Never heard of it.

No matter — it is a novel and not relevant to this discussion. But what is relevant, in my opinion, is that I gravitated towards photography in my early years, in spite of the peer pressure to enter

a more socially acceptable career, because of the personae of the photographers I met. As a group, they seemed to me to be the most interesting — worth emulating — type of human being; curious, tolerant, self-motivated, with broad-ranging interests. I thought: if photography produces people like this then it must be a very important field, rich with potential. I have not been disappointed.

Cameras, Shoes and Other Essentials

Some day our brains will catch up with our instruments,
our wisdom with our knowledge,
our purpose with our powers.
Then at last we shall behave like human beings.

Will Durant

Bill Jay: There's a Zen saying which was often and earnestly quoted when photographers were discussing Minor White and his ilk during the 1960s. It goes something like this: on first encounter a rock is just a rock; on further examination a rock is not a rock; with full understanding, a rock is again a rock. I'm probably trivializing a profound thought which I do not understand, but the quotation reminds me of photographers and cameras. Beginning photographers are obsessed with equipment but there comes a stage when they deny that cameras have any relevance. Yet the best photographers do seem to spend a lot of time talking about cameras again.

David Hurn: Of course. It is important to have the right equipment for the purpose at hand and which is compatible with your own personality. It is possible to insert a screw with a hammer but the job is a lot more efficient with a screwdriver, preferably a power-driver!

A photographer in the middle-phase — dismissive of the camera — tends to feel such talk of equipment gives the impression that he/she is less artistic: "artists don't talk about paint or brushes." In fact, they do. Just recently I was fascinated to overhear two respected watercolor painters heatedly discussing pure white sables versus synthetic brushes.

It makes sense. Musicians discuss instruments; writers discuss word processors, as I'm sure they once discussed types of goose quill; sculptors discuss brands of chisel and methods of welding; and so on. If you aspire to

do anything as well as it is possible to achieve, then the tool, instrument or, in our case, the camera, must contribute to, or at least not interfere with, the final product.

I know that your primary camera is, and always has been, the quick, light, discreet, 35mm type, but that later in life you have also started to use both a 4 x 5 inch view camera and a specially adapted medium-format camera. What are the factors which determine the choice of equipment?

I choose the right tool for the job. In music different instruments were introduced and have been improved for their unique characteristics. So have cameras. To take a simple extreme: the 35mm format allows for light, maneuverable cameras, but it is a small negative with the attendant technical deficiencies. The view camera on a tripod is static, but it produces a large negative. However hard you try you can never produce the tonal range, sharpness and sheer image smoothness of the, say, 4 x 5 inch negative with a 35mm camera. It seems silly to spend so much time and effort, as many photographers do, attempting to wring large-format quality from a 35mm negative. On the other hand, it is just as masochistic to try to cover a quickly unfolding event with a view camera.

Conversely, it is sheer laziness to use a 35mm camera for everything just because the outfit is lighter and more convenient to carry. It is a pity that practically every student of photography buys a 35mm slr camera at the beginning of his/her course work in the presumption that this will do for everything they are likely to encounter. Although it is a versatile instrument, it is unlikely to be the ideal choice for everyone. I wish they had received advice before spending so much money on a camera which may be incompatible with their own personality and subject matter interests. Of course I am reluctant to suggest they have wasted money and should buy another, more suitable, camera.

Ideally, as you say, each photographer would list the subjects in which they have intense curiosity, and analyze how these subjects should be photographed, keeping in mind the individual's personality, and only then select the ideal tool for the job. In practice, this does not lead to a succession of different cameras and formats. Personality is not that flexible or changeable. And personality is what will determine, to a large extent, the choice of certain subjects and ways of working over others. My advice is to stick to one camera and format for a considerable period of time, if only to become so completely familiar with it that you do not need to consciously think about its controls.

That is certainly true in your case. You used the 35mm camera for 40 years before you found it necessary to learn how to load a sheet of film in a dark slide!

I expanded my equipment for two reasons. As I said, the personality does not tend to change very much but the photographer's body does not cooperate. It gets older. Unfortunately this fact leads to a slowing down, a failing of the eyes, a need for less strenuous activity, perhaps a desire to contemplate a little more before acting. I am sure the specifics of aging are different for each individual but the general pattern is definitely reduced physical activity no matter how active the mind. You do not see many war photographers in their 50s. In my case, a frenetic darting about cannot be sustained to the

same degree and I need periods of quieter, gentler activity. I am sure this is one reason why I am so enjoying the use of larger format cameras.

The main reason for the new formats, however, was the demands of a major project which I had been planning for many years and which is now under way …

I am interrupting you because I want to explain this project and then ask you to comment on each section with special reference to the camera format employed. I cannot think of another major exhibition where the distinctly different groupings of images relied so heavily on the choice of equipment …

I will interrupt you because I would prefer the horse to come before the cart. The picture categories, once analyzed, dictated a particular choice of equipment …

Fair comment. Back to this huge project… you have been photographing Wales almost as long as I have known you. As time went by, you began to see it as a major exhibition with three distinct sections. You made a proposal to the National Museum of Wales and this institution was so impressed with the plan that it decided to make the exhibition the centerpiece of its millennium celebration in 1999. Tell us the thinking behind each section.

The idea for the exhibition is to clarify for myself "What is Culture?" — in other words, Welsh culture. Wales is a very small country and photographing there has some disadvantages — when I am traveling abroad and I tell people that I am photographing Wales they often respond, in all seriousness, with "Also dolphins?" — but also considerable advantages. I know every road and have contacts in every area. I feel I know my subject.

I divided the project into three sections, as you stated: 1.) Way of Living 2.) Then and Now 3.) Portraits.

Way of Living …

Culture as a word always provokes polarized opinions. I wanted to use this section to clarify and explain this word to myself. It seemed to me that the culture of a country largely springs from its work base. If that is true then Wales is undergoing a more sudden and violent cultural change than any other country of which I am aware. Until recently the work-force of Wales was predominantly employed in heavy industry — coal and steel. That is no longer true. For example, a few years ago there were more than 100 coal mines in Wales; today there is one. The new work base is in such clean industries such as high-tech laboratories, heritage parks and tourism. This section, therefore, is divided into two parts: the Wales of heavy industry and the Wales of sterile labs. As I had already completed the first part then the second part should be compatible in order more accurately to show the contrast between the past and present. All these images have been shot with the 35mm camera. They are reportage in nature.

Then and Now …

Then and Now is a section which will show the changes in the Welsh landscape over the past 100 years. To achieve this aim I decided to select 100 Victorian albumen prints of historical views from the National Library of Wales and to rephotograph each view from exactly the same location today. My feeling was that by comparing the original scene with the present view then unique and complex perspectives are gained about both the past and the present. In this case I wanted to duplicate the original method of working, as much as possible with modern materials, and it seemed appropriate to use a large-format camera. This allowed me to spend a good deal of time examining the image on the ground-glass screen and making sure the viewpoint was precisely correct. I had never before used a view camera but I had long admired the images produced by landscapist Mark Klett. So, I spent a week or two with him, absorbing everything he did to achieve his results. Besides being a wonderful photographer he is a superlative technician with a fanatical eye to detail so I knew that if I duplicated his methods and did not achieve the same end quality then I would have no excuses, that the fault must be mine.

In general, the large-format camera on a tripod is unsurpassed for fine detail and unparalleled for tonal range but it demands a contemplative mind-set. It was very useful for me in that the slow operation forced me to think like the 19th century workers and I began to understand why they had chosen a certain point of view.

Portraits ...

This section was the result of the Welsh weather, which is so changeable you can experience four seasons in one day! It was a hopeless task to try to duplicate the exact lighting of the scene for the Then and Now landscapes. The best I could do was to shoot at the same time of the year and wait around for long hours until the lighting was adequate. During these tedious waits it occurred to me that I could utilize the time to shoot a series of portraits, a bit like August Sander's collection of archetypal Germans in the first decades of the century. I liked the idea of making rather formal portraits of both the archetypal Welsh and the new Welsh, the recent immigrants.

For this section I decided I needed a camera that was rugged enough to throw in the back of the vehicle on these Then and Now trips, which produced superlative quality when used on a tripod but which was faster to set up and use on passing people than the view camera. This led me to the medium-format, 2¼-inch square camera. A British photographer whose views I respect, Martin Parr, suggested I use the Rolleiflex, a twin-lens reflex. After a good deal of asking around I knew I wanted a post-1962 camera with a f3.5 Planar lens — and I eventually found one. The problem was that I could not focus the camera due to my spectacles and the very dim image on the ground-glass screen. Another friend, camera-maker Jack Tate, came to the rescue. He suggested adapting a Hasselblad prism viewfinder to the Rolleiflex body, which solved both problems in that the screen is very bright and it incorporates a variable diopter lens to compensate for different eyesight problems. So a little perseverance produced the ideal tool for this particular need.

But these choices of camera are exceptions — selected for very specific needs — whereas the vast majority of your images have been taken with the 35mm format.

Only because it is the most appropriate tool for the type of picture I am interested in, and for my own personality. I like photographing people who are generally unaware of my presence and I need to remain discreet, an observer of the event, not a participant. The miniature camera was designed to be fast in action and its small size allows me to blend in. This just happens to be the way I prefer working. Other photographers have their own methods. Edward Weston worked with an 8 x 10 inch camera, taking hours to achieve one image with a technique which I would find unacceptable, yet his pictures are wonderful. I cannot tolerate the school of photography which states to the subject: stand there and stare into the camera, but then Paul Strand did exactly that and produced significant, beautiful pictures.

Every photographer should analyze his/her needs — both photographic and personal — and list the characteristics of the camera which best suits them. For me, the top requirement is a very quiet shutter, and all other controls or features are secondary considerations.

You are not partisan when it comes to brand names?

To a degree. To a small degree. It is interesting to compare the opinions of the most respected photographers. Although there is rarely unanimity in choice of camera or lens, they do have practical experience in such characteristics as ruggedness, reliability, ease of use in unusual circumstances, and so on. But, no, the particular manufacturer or model is not that important. Every maker has spent millions on research and development, and computer design of lenses, which means that most brands are going to perform well and produce sharp images. If you want to name names… for most of my photographic career I used Leicas, for their reliability and quality of optics, but more importantly because of their very quiet shutters. I also like the direct viewfinders of rangefinder-type cameras. I feel as though I am looking directly at the subject, not at an image on a ground-glass screen as is the case with the single-lens reflex.

Unfortunately, as I grew older and needed glasses I could not see the complete frame inside the Leica's viewfinder so I switched to slrs. In fact I use the cheapest, amateur model in the Canon line for one reason only: it is the quietest in operation. I certainly do not need all the bells and whistles even on this camera. It only has one drawback in that its instruction book, under *Precautions!*, says: "This camera is not resistant to water and should not be used outdoors in snow or rain," which could pose a problem in that Wales is a notoriously rainy country. So I carry a second body, a top-of-the-line professional model, for the times when I am shooting in wet weather.

I remember when we would go out shooting pictures together and you would sling a Leica over your shoulder with a jacket worn on top of it. The camera could not slip off, was completely hidden from view, yet it could be slipped out for a quick series of shots and then was tucked away out of sight before the subjects knew you had been photographing.

It is true that the flat Leica-type of camera allowed a greater degree of concealment compared to the bulky slr-type. In practice the more visible slr does not seem as much

of a liability as I would have thought. Perhaps because the camera is so ubiquitous at most of the events I photograph …

More important than the choice of camera is the ease and fluency with which you use it. A good exercise is to sit in a cafe and observe the other patrons. Imagine your eye could be disembodied and float around in space. In a perfect world, where would you position this eye in space for the ideal arrangement of shapes? Then blink at the exact moment when the flux of motion congeals into a perfect picture. This is excellent training and can be practiced in many situations. But you soon discover, if you actually attempted these pictures with a camera at your face, then the power of observation is diminished and that fine details, tiny moments are more difficult to observe. The viewfinder gets in the way.

You can overcome this problem, to some degree, by experience, by shooting a lot of pictures. You learn how to judge the exact field of view of the lens so that you move instinctively into the right distance from the subject and you learn how to operate the camera's controls without conscious thought. All the technical decisions in photography should be so thoughtless that the act of shooting pictures is solely concentrated on the image in the viewfinder.

Which takes a great deal of practice …

Of course. You do not attend a concert and expect the pianist to search for the correct keys! There has been so much practice prior to the performance that hitting the right notes is instinctive. Believe me, that's a lot, lot more difficult than setting a camera's controls. You can learn all you need to know about the technical side of photography in three days, but it takes constant practice to make it so instinctive that you are in the right position, at the right moment, with the right exposure and focus, without any thought about equipment or technique.

We are photographers. The question one must ask oneself is, am I translating what I see in visual terms as well as is possible? In other words, to be able to communicate the communicator must know his craft, both technical and organizational. These are the mechanisms that help him communicate clearly. The photographer who works so clumsily at what he is trying to say that he cannot get it said, however sincere he may be, is at best still an apprentice; at worst, I am afraid, a fraud. There is a constant cry for the new. Some complain of the same old subject matter. They see the answer as a new style or a change of equipment: a bigger flash, a faster motor. History shows us that it is the visually simple that lasts, and that the simple always appears to have an ease of execution. I say "appears" as I am sure that apparent ease is the most difficult of all things to achieve.

It reminds me of a remark by Josef Koudelka who was shooting pictures around my cabin. I couldn't understand what he was seeing, as the images seemed to have no connection with his known work. He said: "I have to shoot three cassettes of film a day, even when not 'photographing,' in order to keep the eye in practice." That made sense. An athlete has to train every day although the actual event occurs only occasionally.

What we are talking about is a special level of commitment. Most photographers do not have it. That's fine. They can still enjoy the thrill of hunting down and snatching pictures. It is a rewarding, satisfying hobby. I include people who are quasi-professionals. But photography is no different from any other profession. In order to operate at the very highest levels, it demands dedicated effort, tenacity and time.

We all know of what I call the talk-caring photographers who are always "involved" working on an indefinable, never-finished project and who produce pictures that have no definable purpose.

The "I want to do it," inspirational phase of creativeness must be joined with the tough, rational working out and development of the inspiration. The latter relies on plain hard work. Many of us have awoken in the middle of the night with a flash of inspiration about some book we would like to write. But the difference between the inspiration and the final product is, in a paraphrase of Dostoevsky:

> an awful lot of hard work,
> an awful lot of discipline,
> an awful lot of training,
> an awful lot of finger exercises, and a lot of throwing away of first drafts.

When I was photographing Graham Greene, whom I have already mentioned, he would write every morning, and then throw it away in the afternoon. He was not writing for a purpose but "just practicing." Incidentally, he also stated that he never started writing a novel until the publisher had given him a title! I do not know if he was being facetious. He was a humorous man. Still, I can believe it.

So can I. Bill Brandt once rather shocked my youthful sensibilities when he told me that he never picked up a camera unless he was on assignment. It has taken a long, long time to understand what he meant.

It is that idea of having a clearly defined purpose for the pictures, rather than walking the streets with a vague idea of "this is what a photographer does."

We are getting away from the photographer's tools.

Not really. A photographer may not just walk the streets but he/she does do a lot of walking, with a purpose, so the most important piece of equipment after the camera is a good pair of shoes. A writer can do a lot of work from a hotel room but a photographer has to be there, so he/she is in for a hell of a lot of hiking.

This is a most important consideration. The shoes must be rugged, durable, suitable for all terrain and weather, so comfortable that they can be walked in all day without discomfort, yet smart enough that the one pair can be worn with a suit to a posh event as well as through the mud at a horse show, or wherever.

When photographers get together my guess is that a comparison of shoes is an inevitable topic!

And so is clothing in general …

This is particularly true if, like me, you need to be inconspicuous in a wide range of situations. I might travel for three months at a time so I think very carefully about what to carry, for minimum weight and maximum usefulness. I need everything for an extended trip to fit into an underseat airline carry-on bag, and all my equipment must fit in one camera holdall. Both bags are carried with me at all times. The holdall is not my working camera bag but is used just to transport the equipment. The clothes bag is a convertible pack which can be carried in the hand like a suitcase or, on unzipping straps, as a backpack.

Now I know exactly what to pack. I wear a suit and pack another. The trick is then to pack for layering — loose clothing that can be added if it is cold and subtracted if it is hot. The first layer is an under-vest made of one of the new artificial fibers which wicks moisture and perspiration from the body. The vest can be used on its own if the location is particularly hot. I carry two of these vests and two others of similar but heavier material. Then I add five shirts, various socks and underwear, all of which, including the suits, can be hand- or machine-washed in two hours.

The choice of suits is important. They have to be light, yet warm, and smart enough to wear at a cocktail reception. Jeans are comfortable and rugged but far too casual for some events. Not only would they make you conspicuous but it is just plain rude to be so casual when others are in dinner jackets. For that reason I always pack at least one white shirt and a tie. It is better to be slightly over-dressed than too scruffy.

I reiterate: this is not a trivial issue. It is a measure of professionalism, how sincere you are in doing the job as well as you possibly can.

Another measure of professionalism in this and every other field is knowing who to contact for specific information and help, especially when away from home.

Most photographers, particularly those who love to travel, collect names, addresses, and telephone numbers in great profusion. These are contacts and constitute one of the photographer's most precious possessions. The problem with the address book is that it is bulky, and prone to wearing out, loss or theft. My answer is the electronic organizer. Buy one which allows you to have a RAM card back-up. In my paranoia I always carry two cards — one in my wallet and one to leave in my hotel room or wherever is my base. In addition, I download the data into my Macintosh computer before I leave home. A true case of belt, braces and a piece of string! If the organizer is stolen or lost then you have to buy a new one, but the relief of slotting in the ram card and seeing all the irreplaceable information come flooding back is worth the money. A word of warning: technology moves so fast that there is no guarantee of long-term compatibility. The last organizer I

owned stood me in good stead for six years. When it was finally stolen, the new model would not accept my back-up cards.

One other item which I consider essential when traveling is a small short-wave radio. There are several on the market which enable me to pick up everything broadcast around the world — especially the BBC World Service!

Talking about non-photographic pieces of equipment reminds me to ask you a question about note-taking. I would have thought, with your dyslexia, that a mini-cassette tape-recorder would have been an essential item in the camera bag.

One of the hard lessons that a photographer learns through experience is that virtually all pictures demand a caption. Indeed, photographic libraries, like Magnum, will not place a picture into the files without the basic Who-What-Where-Why on the back of the print. Even most exhibitions would be better served by having this information available. And, as you say, the most obvious way to collect and store information while traveling is the small tape-recorder. I must confess, however, that although I have owned several for this purpose not one of them has been used in practice. I am not sure of the reason. I find something intimidating about them. My solution is to keep details in small notebooks, inserted into a leather cover, a solution I learned from you. My advice, no matter what system you use, is to write your notes on the spot, or as soon as you have a spare minute. I and everyone else I know find it impossible to recall accurate details at a later date.

So let's move on to another type of containment, the inevitable issue of the ideal camera bag …

My own fantasy is that the bag should be made of some elastic-like material which continuously expands with the addition of new equipment and shrinks to minuscule size as the equipment is taken out. As far as I know it has not been discovered, but how I wish… The reality is that photographers experiment with various bags and probably own several, depending on the needs of the project. But the quest continues. I work out of two camera bags, both small and of the same type, one on each shoulder. The main reason why so many photographers suffer from bad backs is not so much the weight but the tensing of the opposite shoulder when carrying anything on the other one. This is alleviated by carrying a bag on each shoulder as a kind of balance, evening out the pressure. I use both bags whenever possible and it has made a difference. Sebastião Salgado uses two bags for the same reason — but in his case the bags are of beautiful hand-made leather!

You want/need to be unobtrusive yet you are very distinctive among reportage photographers in that you do not sport the photographer's unique fashion statement, the multi-pocketed vest.

For that very reason: I'm trying not to be instantly identified as a photographer.

I am sure the vest is very practical where you need lots of pockets for accessories and there is no necessity to blend in with the people you are photographing, such as for hard news,

nature or landscapes, and so on. For my type of discreet, people-images the last thing I need is a big sign around my neck proclaiming: "I'm a photographer," for the same reason I do not use a camera shaped like a Mickey Mouse mask or wear funny hats! Although I presume there are situations where even these would blend in …

On that fashion highlight we will pause, in order for me to quote the immortal words of Monty Python, "And now for something completely different … "

The Future of Photography

Things are getting faster and faster and stranger and stranger and
it's almost comforting to think that some sort of crystal moment will arrive
and a new order will snap out and suddenly everything will be different.

William Gibson

Bill Jay: We have often remarked to each other, you and I, that on an increasing number of occasions in our various travels and professional encounters we are asked: what is the future of documentary (reportage) photography?

David Hurn: The people who ask these questions seem to fall into two groups: academics who are interested in philosophy and linguistics and who, I suspect, are questioning the "truth value" of this genre of photography; and those interested in the advances of science, and ease of manipulation through digitalization, and the effect this will have on the use, or abuse, of pictures after they have been taken. My opinion is that the future of documentary photography is directly linked to the question of morality.

I want to return to the issues of truth and electronic imagery, but first, tell us what you mean by photographic morality, as a foundation for these later issues.

Morality means nothing more than doing what is unselfish, helpful, kind, decent, and doing it with a reasonable expectation that in the long run, as well as in the short, we will not be sorry for what we have done. It means we protect our subject matter when we shoot. It means we do not lie about or abuse it in order to increase our chances of being published. It means we do not lie about or abuse it to gain status for ourselves in the gallery or fine art world. Now this moral rectitude is particularly difficult to maintain if we live in countries in which the opposite is rewarded, in which escapist models and ethical evasiveness are rampant. Without compromise we must attempt to present our inspiration, our representation, in a way

that makes it credible and vivid to our audience. Not only information to the intellect, but feelings to the emotions. But sincerity is not enough. Very few people who take photographs are visual. They do not see. They record — but that's not seeing. It's very hard to see.

The issue here is a fundamental rift between photographers: those who assert that the medium is open to endless manipulations in order to satisfy the needs of the creative artist, and those who believe that the camera's unique ability to show what things look like is best explored with a direct, straight technique — and that it is the flux of life which is ever-changing in front of the camera, that it is each photographer's unique life which constantly presents new visual challenges.

We live in a world that changes more rapidly now than it ever did before. To be a photographer in a world which changes perpetually we must be comfortable with change and to be able to adapt our views when confronted with new truths. We must not be blinkered by ingrained prejudices. We must be willing to explore many aspects of life and follow wherever the flow takes us. Photography reflects true life and life changes. People forget the ever-recurring problems and continually need reminding. To quote the author, John Gardner: "Insofar as literature is a telling of new stories, literature has been exhausted for centuries but insofar as literature tells archetypal stories in an attempt to understand once more their truth — to translate their wisdom for another generation — literature will be exhausted only when we all, in our foolish arrogance, abandon it." That is also true for photography.

The future of reportage photography, in your view, is not dependent on linguistics or technology but on the instant need of some individuals — who might be photographers — to confront new truths in their lives, and to confront them merrily.

Yes. Those individuals have no fear or shame in being identified with a willingness to fight for the right to live in a decent — dare I say it — an honest world. The future relies on the individual intellectual integrity of the people actively involved. It does not rely on passive analysis or on fringe groups. If people wish to deliberately lie and distort that is their conscious choice. The future of reportage photography lies with photographers and with people who publish, exhibit and collect photography. They can make choices.

I believe that in a society in which every individual opinion counts, photography at its best has a unique ability to instruct; to help make alternatives intellectually and emotionally clear; to spotlight falsehood, to spotlight insincerity, to spotlight foolishness, to bring people together, to break down barriers of prejudice and ignorance and show ideals worth pursuing. We should trust the peculiarities of our medium. And if we are truly curious or fascinated or profoundly interested in our subjects then we are less tempted to interfere, to control, to change, to improve. We have respect for the event, we do not wish to influence or alter it. To the extent that we know that photography is not perfect, to the extent that it is possible for us to be non-intrusive, non-demanding, non-hoping, non-improving, to that extent this subjective activity achieves a particular kind of objectivity.

If we are realistically aware that this love, this involvement, brings with it a certain kind of blindness, I feel certain it also produces a certain kind of truth.

I love those phrases, "a certain kind of truth," "a particular kind of objectivity." They imply that there is a not-knowing which is valuable. One of my teachers was the philosopher-poet-artist Michel Butor who once told me that truth was like a photograph in which thousands of different shades from black to white, and including both extremes, were necessary for full revelation. But, of course, most people in this day and age insist the truth is black, or white, and deny the beauty of the whole. I often think of Butor's words when I hear my colleagues defining words like truth, reality, and meaning in an academic setting.

Whole photographic departments are now engaged in defining things. Not too many pictures are taken.

To quote Robert Adams again: "Philosophy can forsake too easily the details of experience… many writers and painters have demonstrated that thinking long about what art is or ought to be ruins the power to write or paint." I think that is true for photographers.

If I am not careful I suppose I/we might now have trouble with the word truth. Linguistics games can go on forever. Wittgenstein is often quoted as implying that truth does not exist but, on checking, what he did seem to say was that "certain forms of truth which do exist are philosophically inexpressible."

Perhaps I will be seen as an anti-academic, which I am not. It is the seeming total dominance of academia by slovenly academics that is objectionable. They destroy young people of potential who might enjoy nosing in other peoples' business. Anyway, in my experience, the photography academics do not know what they are talking about, even if it were relevant. I was discussing this frustration of mine with the chair of a university philosophy department when she stated that most academics in photography of her acquaintance would not even pass the interview to become a beginning student on a rigorous philosophy course!

Let us quickly admit that the finest photographers out there in the world are not averse to conversation or ideas …

No, indeed. I recently spent a memorable evening in London. It started with a telephone call on a Sunday night. A photographer friend was going to be in London for the evening of the next day. We arranged to meet. The situation snowballed. I made two quick calls so that she would be surprised by two more friends. I took a train from Wales on the Monday afternoon, looking forward to a grand meal with my seldom seem colleague. On arrival an added joy was that three others were also in town. The grapevine had functioned. A picture editor and an editor joined in, and we were now nine. For three hours, over dinner, we talked photography. Not the language of academics, or of photographers who pay attention to academics — a language of seldom used words and full of fine distinctions that only non-photographers seem to think profound. No, we talked of the subject matter we were interested in and the individual way we each dealt with the problems incurred.

We talked of the penalties of actually living with the homeless. Of surviving while marching with the starving. Of the traditions and preparation of the Mummers Parade in Philadelphia. Of the concept of loneliness. Of a Pope's visit and the links to the political situation in the surrounding countries. Of the chorus of the Welsh National Opera and the effect on one of standing four feet from 42 singers in full voice. Of what is culture. There was even talk of the problems of picture editors — surprisingly, sometimes our friends. We talked of various magazines and how they could help us and us them. Of whether a subject warranted an exhibition or even a book. Essentially, we discussed how can we communicate in a real world and stop too much distorting of what we had to say.

I slipped in the question, "What is the future of documentary photography?" I sensed that they had a relaxed understanding of the question. They did not assume negative connotations. They did not contemplate linguistic traps. If there was a problem, they saw it as a problem of how to deal with too many ideas, and the clarification of those ideas — of not enough time to do what one wants thoroughly — and of the personal problems of getting older (mainly bad backs).

Ah, the bad back, again! I have been waiting all my professional life to read a book which mentions the most frequent and commonly talked-about hazard of the photographic profession. And now it has, at last, happened and the book in which "bad back" appears is ours. How satisfying! I will mention, in passing and for the edification of the reader, that David, whenever he visits me, sleeps on a thin foam rubber pad on the floor with a specially designed neck pillow.

From low-tech to high-tech, let's move into another aspect of the future: electronic imagery. The two areas which I would like to discuss are the transfer of existing images to electronic exhibitions and the ease of manipulation and your reaction to new images afforded by digitalization.

You are asking me to predict the future. The advice in this book is based on a lifetime of experiences and, by definition, I have no experiences of the future. But I would agree with the astronomer/futurist Arthur C. Clarke that "The future isn't what it used to be." Changes are occuring at such a rapid pace that whatever we discuss on this topic, you can be sure that there will be new questions, new opportunities — and new problems — by the time this book needs a new edition.

True, but some factors which are shaping the future of our field are already in place, such as web sites for the display of electronic exhibitions. It is estimated that the web will have 100 billion pages by the year 2005. That's 16 pages for every man, woman and child alive on the planet. Photographers are already taking advantage of this technology to produce displays of their images. It seems that every student is encouraged and taught how to produce their own web sites before they have anything of value to put on it.

Surely this is a new opportunity for photographers of every level to reach a wider audience.

Perhaps for some … but I am a little skeptical that these sites will ever fulfill the average photographer's dream of quick and wide acclaim.

High-profile photographers, such as Sebastiao Salgado and Annie Liebovitz, have very professional, and therefore expensive, web sites devoted to their work and can expect huge numbers of visitors. The Selgado site averaged 100,000 hits per week for the first six weeks after its launch. The Liebovitz site was even more popular.

But these are famous names whose images are popular whether in exhibitions, books or web sites.

By contrast, the average photographer, without a famous name, who has created his or her own web site, is unlikely to receive any more visitors to it than would an exhibition of the prints hanging in a local gallery. And that is not many. These poorly conceived and designed amateur web sites, swamped by billions of others, are unlikely to be found by chance, and few people, apart from friends and acquaintances, will search the web under an unknown photographer's name. Therefore the site will languish, unvisited, in a tiny backwater of the vast web ocean.

For the average photographer the home-grown web site is not the miraculous answer to the problem of reaching a wider audience.

Let us attempt to reach some conclusions about web exhibitions, based on what you have said. A photographer interested in using the web to reach an audience should:

a) keep in mind the intrinsic characteristics of the web before planning the exhibition. The computer screen is not an original print and its relatively poor definition precludes images which rely for their merit on high definition and subtle tones.

b) collaborate with the best web designer you can find or afford. The top photographers have collaborated with very professional specialists. This makes it even more important that your site is of a very high standard.

c) invest in a professional service which regularly makes sure that your site is updated and linked to major search engines. There is no point in creating a site if no one can find it.

d) specialize. If your images offer a clear difference from other sites it is more likely to be accessed.

The last point is very important. Unfortunate as it is for the ego-driven, your name, even with "artist/photographer" attached, is not going to attract visitors to your site. Nor is a generic category such as "landscapes," "portraits," or "travel." For these topics a potential buyer or viewer is far more likely to go directly to one of the major image banks. The more specific and unusual your topic, the better. Your images are more likely to be found under precise themes, such as pencils, peppers or tide pools. These are not recommendations, merely examples!

Again, this is why it is so important to consult a web professional who knows how to brand your images for the search engines through which potential visitors will find your images.

This is all good advice for photographers who are interested in personal exhibitions on the web, with the hope that someone will inquire about acquiring an original print for reproduction or exhibition. But the situation is far more complicated if the actual digital images are intended for marketing and publication.

In this case, the individual is in direct competition with stock agencies such as Corbis and Getty Images which between them have over one million images online. These agencies have bought up scores of archives, museum collections, news services as well as the life work of thousands of photographers. Getty Images alone has invested more than $30 million in the past few years on electronic infrastructure, scanning and keywording.

Most scan sizes for these online images seem to be around 50 megabytes each. The sites are run by very experienced professionals, many of them hired from well-respected print agencies. It is difficult to see how the average photographer's web site can compete in the arena, given the huge costs involved in setting up the site, scanning at very high resolutions, maintaining the site and its continual updating, especially as Corbis and Getty Images charge relatively little for the use of their images.

I think the important point is that every form of presentation — newspaper, magazine, book, exhibition, and all the variations within each medium — has its own intrinsic demands. Now we must add the web to the list with its own needs. But, so far, photographers have not analyzed the nature of those needs, and we have a plethora of web displays which are merely scattered single images with no purpose, idea, linking theme, or cohesion. That is not, in my opinion, the best way to utilize the brand new means of presentation.

But you are not suggesting the special demands of web exhibitions are beyond photography's means, or that just because present displays are unsatisfactory they cannot be successful …

Not at all. Indeed, I would go further. It is the "special demands" which can help us define what constitutes a successful electronic exhibition. The very limits or weaknesses can lead to an understanding of the strengths. Photographers have always excelled at working within narrow briefs or controlled directions.

Not only photographers: there's the wonderful story of an 18th century king, George II, who commissioned a composer to produce an orchestral suite under the following conditions: it had to last as long as it took for a boat to travel up the river Thames from Hampton Court to Windsor Castle; the number of musicians was limited to the boat's capacity; the music must be loud enough to be heard by people on the river bank, and so on. That's a pretty tight brief. Indeed, at a rehearsal the boat sank, and the piece had to be rewritten for fewer musicians. The result was George Frideric Handel's *Water Music*, which is still popular today.

By the way, the fine British film, The Madness of King George III, came to America and the distributors had to omit the III because of concerns about people assuming they had missed Parts I and II. That was merely a touch of levity to show we have a sense of humor! Back to the issue …

There are all those painters of the past whose patrons, whether the church or princes, dictated not only the contents of the work but also exactly where it should appear, often an awkwardly shaped area of wall or ceiling, and then determined the length of the contract. There is a modern myth of the creative artist whose genius only shines when allowed full freedom from all constraints. In fact, the opposite seems true: a tight brief channels the otherwise free-flowing talent into a concentrated effort.

My mind is now leaping to the Farm Security Administration ... how often have I heard the fallacious notion that the photographers traipsed across the USA doing their own thing. In reality, Roy Stryker provided each photographer with a very specific shooting script, an "official textbook" on the sociology, politics, demographics, and so on, of the area that they were to visit — North America, by J. Russell Smith — and made sure that each photographer became a mini-expert in their assigned subject before he/she was sent into the field. Carl Mydans, one of the neglected photographers of the F.S.A., tells a great story about this need for preparation and research. He was assigned by Stryker to go down to the deep South to do a story about cotton. As he was leaving the office, Stryker casually said to him: "I assume you know something about cotton." Mydans said: "No." Stryker told him to put down his camera bag, then he turned to his secretary: "Cancel Carl's reservations." Mydans later recalled: "We talked all afternoon, then at dinner, and all night, and when I left the next morning, I knew something about cotton."

I think we have made the point that photographers — as well as painters, writers and all creative people — have often produced their best work when working under an exacting set of conditions, whether self- applied or provided by others. My guess is that the history of photography abounds with examples which would confirm this idea.

The principle holds true not only during the production of the project but also during its presentation.

It always takes a while to learn the particular demands, the special characteristics, of the presentation method. This is not the place to ramble sideways into the history of photographic exhibitions, except to point out that the typical 19th century exhibition often contained thousands of images, with no selection process, in a multitude of idiosyncratic sizes and frames, jammed together up to the highest corners of the ceiling, all competing with flocked wallpaper, gas fittings, windows, drapes and furniture. Those pictures which would not fit on the walls were dumped in a heap on a central table. It was not until Frederick Evans began organizing the Salon exhibitions in the 1890s that photography displays began to receive some consideration in terms of isolation, spacing and design, and here we have the beginnings of clean, non-distracting walls and consistency in presentation. It took a long time for the exhibition needs of the photographer to be developed and refined. A similar long-term process governed the development of the picture essay in periodicals, and in the special characteristics of, and differences between, the wall exhibition, magazine layout, picture book, original print portfolio and so on. Suffice to say that each presentation method with its own internal logic and tight strengths (and weaknesses) had to evolve into its own special, effective form. And the same will occur to electronic exhibitions.

Today we need individuals of insight to write the rules of engagement for this new form of exhibition. It is an exciting challenge. My guess is that photographers and web experts will collaborate, initially, and define the parameters of the brief which image-makers will then use to create effective exhibitions specifically for the electronic gallery.

And now we should talk, briefly, about images created electronically with digital cameras. A few years ago digital cameras were regarded as expensive toys. Today, with plummeting costs, rapid increases in resolution and an ever-widening choice (there were more than 60 models on the market at my last count) it is evident that digital cameras are becoming viable alternatives to film cameras, especially for the amateur. It is estimated by market analysts that by 2005 there will be more digital cameras in use than film cameras.

There is no doubt that digital cameras are replacing the models using film. But there are a couple of worms in the bud which spoil my appetite for the new technology.

For the amateur it just means that boxes of uncatalogued, dusty machine-prints will be replaced by uncatalogued images on some sort of storage device such as compact disks. Although the space-saving is considerable, the images are no more accessible so not much has changed. Also, with rapid changes in storage systems and software, who knows if the disks, or whatever, can be even opened and viewed in a decade or two.

For the serious photographer, the problem is also one of storage. Discounting the very real problem of ever-changing storage technology and obsolete software, a bigger issue is one of efficiency. In order to digitally store the equivalent of a 35mm film and contact sheet, the photographer would need to scan 36 images at 50+ megabytes — that's 1,800 megabytes for *every film*. The reasonably active photographer would fill up the hard-drive of a good computer every month. Of course, storage methods will change and become more convenient. I am merely pointing out the efficiency of the present negative/contact sheet system.

And to think that as recently as 1981 Bill Gates, CEO of Microsoft, said that "640K [of memory] ought to be enough for anybody!" But back to your point: digital photographers would argue that they do not need to save every image because one advantage of these cameras is that the images can be edited in-camera and only the best saved.

For some types of photographers that may be true. But for the documentary/news photographer such instant editing raises a serious question about the historical record. Who erases the unwanted images, and on what basis?

Often the photographer is not the best picture editor, and the picture editor will have a bias about which images to keep/discard depending on the story. Neither the photographer nor the picture editor is mindful of the historical record at the time the images are in the camera. Experience shows us that in fifty years time a different editing is often the most useful. So the edit-as-you-shoot solution to storage problems is not really editing but a systematic destruction of potentially valuable work.

The strip of negatives/contact sheet is still the most efficient method of storing all the images; it allows for some sort of authentication of the image because you can see what was taken prior to, and after, the selected picture and this reveals context, an important aspect of reality.

Also, the edit-as-you-shoot approach would certainly change the working attitudes of the photographer.

With film cameras you cannot see what the camera has captured at the moment of shooting. So the photographer must keep shooting through the event as it unfolds.

With digital cameras the tendency always will be to look at the screen to see if the image is adequate. Meanwhile, the event might have changed irredeemably. Once the photographer can instanly check on what was pictured then the chances are that he/she will stop shooting if the image is a reasonable one. The camera, therefore, has imposed on the photographer a different, and less efficient, way of working.

It is interesting that so many digital cameras are being marketed with the primary sales appeal that amateurs can, and therefore will, manipulate the images before storage. At the same time serious photographers are enthusiastically embracing the digitally manipulated image and developing a whole new field of art.

At present the manipulated, digitally created images seem to be boring tricks by weak photographers. But the time is quickly approaching when the digital photographer will be so skilled and adept at the computer's controls that these will be mere tools for the creation of fantastic (in both senses of the word) images. I am waiting for the Marc Chagall of electronic imagery to arise. It will be then a pleasure to look at, and appreciate, electronic imagery of lasting merit, although I am not in the least interested in personally becoming involved with that type of work.

You have spent your life attempting to master a particular kind of photography. There are many bands in the photographic spectrum. Because you happen to reside in a particularly intense one, that does not invalidate any of the others.

No. But I am concerned, if that is not too strong a word, at the blurring or overlapping of bands, as you put it. That is, where an image purports to be a truthful representation of reality but in which manipulation has occurred. Of course, photography is replete throughout its history with tampered reality. The only difference now is that the manipulation is much easier to achieve and is virtually undetectable.

Yet there seems a very fine dividing line between the alteration of tonal values through dodging and burning, and the new ability to move an object a few inches to the left for a better picture.

I am sure that many reportage photographers will take advantage of this new tool for image re-arrangement. They will be able to achieve what took Gene Smith many, many

hours in the darkroom — or, in his case, a re-arrangement of the elements in front of the camera. I am merely asserting that this ease of manipulation through digital controls after the image has been made would, for me, reduce the satisfaction of attempting to capture a perfect image in real life. To some, this might seem masochistic but it is the very difficulty of the effort which produces the satisfaction.

Remember the Pedro Meyer lecture we attended during which he uttered one sentence which clarified the issue for me. He said something like, "Perfect images are so difficult to find in reality but now I have a tool for correcting photography's problems."

I remember your outrage! As we left the lecture you were fuming that it is the difficulty in capturing wonderful images that makes it such a meaningful challenge. But I think you were somehow outraged that these manipulated images masquerading as documents of reality were being foisted onto a public who would not know the difference.

You are right, but I want to clarify my remarks. For a photographer to admit that he is not capable of grappling with the problems which a whole history of photographers have also tackled — and succeeded — is not for me to comment on. My frustration was that this photographer was giving a public lecture to an audience of primarily students and seemed to be implying that when faced with a problem, take the easy solution. It is the willingness to tackle and solve the difficult that makes Alex Webb, Gilles Perres, Lee Friedlander, and others, great photographers. What is the point of a Friedlander photograph if its components were put together in a machine? If any of these photographers were to decide in the future to manipulate images in the computer, my guess is they would tackle a new order of problem and not use it as an easy solution to an old problem.

When the public at large is gaily amending, improving, altering snapshots before they are stored as the family record, then we have a whole new situation. The public will not presume that the photographs which surround them — in newspapers, magazines, advertisements, billboards, even television — are truthful. The presumption will be that they have been manipulated.

I agree that we are entering an interesting new era in which the mind-set of the people towards truth will be based on a pre-Renaissance idea of symbol, magic, ritual. But that is another topic. Back to the present: it seems that the transition period, from photograph-as-evidence to photograph-as-lie, which has already begun its inevitable seepage through the culture, is the time of greatest confusion.

I am not at all convinced the issue is or ever will be quite so problematic as you have said and written about in various articles.

For example, the written word has always had the same ambiguity. Words can be massaged, doctored, reassembled and slanted in a myriad of ways. Who can tell if any statement is true? One way, to answer my own question, is to look at the source of the words. Do we trust this particular author? Another is to trust the context. If you read an article in a sensational tabloid you do not expect the truth, the whole truth and nothing

but the truth. You expect to be titillated and entertained with trivia. On the other hand if you read an article in *The Lancet, Nature,* or *The New England Journal of Medicine,* then you would expect it to be factually accurate. So there is a commercial or marketplace sorting/sifting process under way.

I think the same is true of photographs; that there will be some contexts which we will trust more than others.

Here's an area where I disagree; the photograph is a special sort of symbol which is not like an article of words; by cultural consent we have invested the photograph with a machine-like relationship to truth to a far greater degree than any other method of communication; that photographic truthfulness is not dependent on knowing who made the image; and my hunch is that there are many more gray areas where photographs may or may not be more truthful than the tabloid/scientific duality. But this book is focused on you so I will leave these arguments for another time and place.

Whatever the future might hold, I do know one fact: it is a simple problem for me, and photographers like me, to solve right now. For decades we have stamped the backs of our prints with a warning not to crop the image. That works. It is very rare for a magazine to disregard this demand. In the same way, I can stamp my prints: this image must not be manipulated in any way, including electronically. Most journals which are likely to publish my pictures will respect my wishes.

Prior to the introduction of the half-tone reproduction process, periodicals often published wood engravings with the caption: "from a photograph by... " The purpose, of course, was to assert the accuracy or truthfulness of the scene. It will be interesting to see if today's magazines will carry the caption: "from an unmanipulated photograph..." if they want to stress its authenticity.

I expect they will, at least during the transition period.

Will this reduce the markets for unmanipulated images when most periodicals will be changing to digital illustrations?

Yes — but that is to my benefit! When nearly all magazines changed to color the fear among black-and-white photographers was that there would be fewer outlets for their work. And that was true. But even though there were fewer magazines publishing black-and-white work there were even fewer black-and-white photographers remaining. The result was that the ocean become a pond but that they —the black-and-white photographers — were now very big fish!

The same situation developed when Henri Cartier-Bresson insisted on using a Leica by natural light. Instead of this insistence cutting him out of the field he was suddenly in great demand because his work was different from the hordes of photographers with large plate cameras, giant flashbulbs and tons of gear.

I think this is what will happen in the new age of electronic illustration. Those of us who make straight fiber prints in black and white will have a smaller market but there will be so few of us to service it.

And the original prints will gain value because of their rarity.

Undoubtedly. When the digital camera/electronic image becomes ubiquitous then the old-fashioned silver print will have an automatic value which is not true at present. As a growing market for my photographs is among collectors, galleries and museums, I am making 25 or so prints of the images most in demand before silver-based papers disappear. This will be my retirement income. So there are many benefits to me in sticking to what I know/do best and hoping for the hastening of the digital crowd!

Some Photographic Myths

Understanding is the real satisfaction.
[It is] the only pleasure that is not followed by remorse.

Socrates

In this section we want to touch on a several issues which seem confusing to many photographers with whom we have talked over the years. A few of these myths have been mentioned in previous sections but they were not explored at the time, perhaps because they were not germane to the points being made. All of these myths deserve even more detailed treatment but we hope our joint comments will serve to open discussions and debates with friends and colleagues. This section is not in the form of a conversation, but has been written by us jointly.

Myth No. 1:
Photographers are the best editors of their own work
No. The myth is that the best photographers are the only ones who have the insight and ability to select the best images of their own work for publication or exhibition.

The myth arises because the photographer is often too close to the subject matter, invests the content with emotion which might not be present in the picture, and believes that in order to be "true to myself" he/she has a special insight into the work. But the best editors/selectors of images are those who are capable of divorcing themselves from emotion when judging their own (or others') work and assessing picture merit dispassionately and with a cold logic.

Some photographers of the highest rank are capable of this detachment; most are not. Indeed, many of the best picture editors are not photographers at all.

An instructive example of this myth is the career of W. Eugene Smith, who became a legend by resigning from *Life* magazine because he was not allowed full control over picture selection. Photographers applauded Smith's action as a case of artistic integrity in the face of corporate Philistinism. Unfortunately, the facts are that all of Smith's greatest and best-known work was edited by *Life* staffers. When he was given the opportunity to edit his own work the results were disastrous, as epitomized by his *Pittsburgh* essay. He shot over 11,000 negatives in one year (1955), printed 7,000 proofs, and selected 2,000 images. The only publication willing to use the result was *Popular Photography Annual*, 1958. It used 88 images over 34 pages. The images were accompanied by Smith's own labored, tortured prose. Even on Smith's terms, the whole project was a failure.

W. Eugene Smith had complained so often about his lack of artistic control that we thought it would be interesting to give him 16 pages plus front cover in our magazine *Album*. He was told his choice of images and their layout would be followed without the slightest deviation. The result was so bad that we felt obliged to print a disclaimer, telling the reader that the images and the layout were made solely by Smith. There is no disputing the fact that Smith was a superb photographer, but a poor editor.

In the same way that writers are enhanced by a close relationship with a good editor, so a photographer can benefit from the insights of a good picture-editor.

Our advice to photographers is: find an editor you can trust, one who is working at the highest possible level of professionalism. This does not imply you must blindly accept and follow this person's recommendations; it does imply that this editor might offer you a clarity of insight into your own work which you would not achieve on your own. The very best photographers are usually very humble about seeking advice from colleagues they trust.

Myth No 2:
Photographers are their own best writers/designers

The same principles apply. It is very, very rare for a good photographer to be an equally good writer or designer. Both fields have an abundance of individuals who have spent years of hard work mastering the nuances of their crafts. It is the height of arrogance to presume that photographers can do just as well without the equivalent amount of invested time and effort. Does the skill of the writer or designer suddenly become irrelevant once a photographer enters the scene? Hardly. Just reverse the situation in order to understand its absurdity. We would be offended if a fine writer or a successful designer picked up a camera and instantly declared themselves a great photographer!

David: If I have a choice between writing my own text or collaborating with someone like Graham Greene, the insistence that I do it myself is ludicrous.

Bill: Many photographers write very well when explaining their methods and intents (see *Photographers on Photography*, edited by Nathan Lyons) but that is not the equivalent of excellence in writing to accompany a photographic essay. Philip Jones Griffiths wrote well in his classic book, *Vietnam Inc.*, but most photographers' images are enhanced by collaboration with brilliant writers. Examples of such effective collaborations would include: Fay Godwin/John Fowles; Rosamund Purcell/Stephen Jay Gould; Paul Strand/Basil Davidson; Chris Killip/John Berger; Bill Brandt/Lawrence Durrell, among others.

Our advice to photographers who are preparing a magazine essay, a book or an exhibition: collaborate with the best writer and the best designer you can find.

Myth No. 3:
Photographers are good printers

We have all seen many exhibitions even by well-known photographers in which the enlargements fall short of the highest standards of craftsmanship. The usual justification is a variation of "but it's all my own work," which sound to us more like an apology.

The fact remains that printing is a highly skilled profession that demands a great deal of time (and enthusiasm) to master. Some photographers have the interest in fine printing, and have invested the effort to become extremely proficient in it. Most have not. In reality, a professional printer, working in collaboration with the photographer and sensitive to his/her needs, is likely to produce a far superior result. It is preposterous to think that a photographer can make enlargements to the same standards as a professional printer who does nothing else all day, every day.

If it is any consolation, most top photographers use renowned printers for their final prints. Picto, a lab in Paris, prints the negatives of Robert Frank, André Kertész, Josef Koudelka, Henri Cartier-Bresson, among others. That's not a bad group of photographers! What they understand is that the merit of the image is only as good as the weakest link in the chain. There is hardly any point in mastering all the other links towards fine photography only to falter at the final one.

Most photographers, especially those who hope to sell their original prints in the burgeoning art market, would do much better by accepting the idea that a professional printer is going to produce a better result than a half-hearted, part-time one, like the photographer. Print-makers have long understood this point. Most etchers, engravers, lithographers, and those whose medium is aquatint, photogravure, collotype, or any other print-making technique, employ master-printers, under the supervision of the artist, to produce the final editions.

To be fair, there is a notion among some art-photographers that a particular sort of magic, spiritual resonance, or special personality transfer, takes place when the artist handles the paper in the developer. In some cases, the photographers assert that a certain essence or aura can be transmitted to some prints as opposed to others from the same negative, with the result that the former are priced thousands of dollars more. In our effort to be non-judgmental towards these artists we will merely note that such mysticism equates with bullshit.

Myth No. 4:
Commerce is corrupt, art is pure

A peculiar notion is prevalent among artist-photographers which equates certain kinds of money with a lack of merit. This fallacious assumption leads to some odd ironies and strange consequences.

For example, if the institution which pays the photographer is, say, a magazine then he/she will do the job less well or less sincerely; if the institution which pays the photographer is, say, an arts agency then he/she will do the job with merit and integrity. There are several problems with this scenario.

The idea that professionals are commercial hacks but artists are free and independent image-makers wipes out practically the whole history of photography. Almost without exception, the great photographers of the past, whose images are revered by contemporary artists, were professional photographers whose main goal was to earn a living from the sale of their prints.

Sincerity is not the prerogative of the artist. Richard Avedon is a great photographer largely because he cares about fashion, to the point of obsession about every tiny detail of the process. Artists could learn a lot from this attention to detail. The fact that Avedon makes a lot of money is irrelevant.

On first encounter the idea that seemingly impartial arts agencies will provide grants and fellowships to photographers might imply that this route to making money is less corrupt than the commercial method. It has been both our experiences that the art world is far more corrupt — in its subjectivity, nepotism, reliance on shared favors, dependence on who you know — than the professional arena.

There is a rank hypocrisy in the idea that art is free of compromise. Here's a simple test. An art agency is offering a major grant to photograph businesses and homes being built directly on top of the San Andreas fault in California. It is amazing how many photographers suddenly have a passion for that subject, who previously would never have considered it!

The bottom line is that, unless you have a private income, it is necessary to make money with your photography. There is no merit in starving to death or not having enough money to buy more film in order to shoot more pictures.

Bill: When I worked as a picture editor there was not a single time that the magazines published an essay by a "name" photographer if an unknown produced an essay which was better for the publication (in that it was of greater interest to our readers). I fail to see how this is a more corrupt system than art grants which tend to go to those with the right buddy contacts. Since I have been in the arts of academia I have rarely observed an honest, professional appraisal of merit being the criteria of selection for any grant or award.

David: The great majority of jobs in photography are done by freelance photographers. It has certainly been my experience that if you produce quality work it is ultimately published. However, I do believe that part of the process of producing quality work is to understand that you must be communicating to your general public information that is not boring to them. A test I often suggest to photographers is to ask themselves: "If I were a picture editor/curator would I publish/exhibit these pictures?" It is amazing, if one is honest, how rarely you can come up with the answer "Yes." The trick is to find projects on which you wish to work which also have a chance of fitting into the editorial policy of various magazines or of producing a visually arresting exhibition. What I often do myself is not think in terms of one thing I wish to do but of half a dozen. Having begun to research them I then begin to make a decision as to which one I will do best on many criteria, one of which might be "Does it have any sale possibility, i.e., is the public interested?"

Our recommendation is to select your projects with care, using the analysis which we discussed earlier, and to realize that if several essays have equal interest to you then it is no compromise to work on the one which is appealing to others. This applies to all styles of photographing at both ends of the art-professional spectrum. We all know photographers who cannot photograph because they did not receive an assignment or an expected grant. This usually means they were insufficiently enthusiastic about the project to begin with. The answer is to get on with the project, determine that, yes, it can sustain your interest, and then find any method to support the continuing photography.

Myth No. 5:
Photography is about talent and instinct

Both of these words, "talent" and "instinct," are comforting to second-raters. They imply that some people are born with a special gift for making photographs (!) and that no planning or thought is necessary because such photographers mysteriously sense a picture and, therefore, everything that they produce is of merit. This attitude is particularly prevalent in the hot-house, rarefied air of academic art. Time for a reality check.

No one is a born photographer. That's absurd. Certain people may be born with genetic traits which are useful to becoming a photographer at a later date, among which physical fitness, visual acuity and, above all, a lively curiosity about the world, would rank very highly on a list of desirable characteristics. There are many ways a person may choose to transmit the object of his/her curiosity to others. Photography is one of them. That's when the hard work begins.

Examine the lives of people who have truly excelled in any of the arts — music, theater, dance, sculpture — and they all have one characteristic in common: the capacity to commit themselves wholeheartedly to their chosen disciplines. They do it every day. No excuses. A dancer, for example, cannot compete at even the lowest level without years of daily exercising; a pianist cannot perform at a concert after having taken a nine-month break; actors are not given roles in a Shakespeare play because they feel they should be. So why should photographers expect to receive one-person exhibitions or publications without similar dedication? Are the standards in photography so low that success can be achieved with so little effort? Of course not.

The fact is that photographers at the highest level have committed themselves to continuous and dedicated practice. Fierce single-mindedness and self-motivation are essential. It is very, very rare to find a part-time photographer in the front ranks. This leads to an uncomfortable conclusion.

The two routes by which a photographer can earn a living in the medium is as a teacher or as a professional. The artists of the medium nearly always end up in academia. Very few survive as photographers at the highest level. Sensibly, they have created an internal system of shared exhibition venues and publications where they are competing only with each other, not with the best photographers throughout the medium. That is why documentary photography is at such a low level in so-called art venues patronized by academia. Some artists do indeed thrive with college/university patronage. But these are the exceptions, not the rule.

It is no coincidence, therefore, that the very best photographers of the past and present — whether reportage photographers or artist-photographers — have been/are professionals. The case of Walker Evans is instructive because he has been called one of the great artists of 20th century America in any medium. Look closely and nearly all his major images were taken on assignment, for *Fortune* and *Survey* magazines as well as for The Farm Security Administration. Other renowned artists in photography who have earned their living as professionals included Weegee, Joel Meyerwitz, Robert Frank, Garry Winogrand, Duane Michals, Eugene Richards, Burk Uzzle, Elliott Erwitt, Jeff Jacobson and Diane Arbus.

This is not a coincidence. Through professional photography they practice their craft on a continuous basis and, in so doing, become better at it.

Myth No. 6:
The it-has-been-done-before syndrome

One of the most pernicious and destructive remarks which can be made to a photographer is that "it has been done before," with the clear implication that any attempt to rephotograph the same subject will be a waste of time, if not unethical.

Of course "it" has been done before. I doubt if a photographer can think of a subject which someone, somewhere, at some time has not explored. Should photography, therefore, come to a screeching halt?

In fact, the opposite is true. Photographers should actively look for ideas, attitudes, images, influences from the very best photographers of all ages. You cannot learn in a vacuum. The whole history of photography is a free and open treasure trove of inspiration. It would be masochistic to deny its riches and usefulness.

For example, I [David] am thinking of expanding my sculpture essay to include war memorials. I feel sure I was very much influenced by Lee Friedlander's book on monuments, on which he has said he was influenced by a story in *Fortune* by Walker Evans, who may have seen Emil Hoppe's book on monuments, who could have seen Eugene Atgét's images in old Paris, who probably knew of the French Historic Monuments Commission, which assigned early paper-negative photographers of the 1840s such as Charles Marville, Henry Le Secq, Charles Negre and others. This tree of influence with many branches extends from today back to the dawn of photography.

Our advice to photographers is best expressed by Calvin Trilling: "The immature artist imitates; the mature artist steals."

So steal from the best. Surround yourself with people who are better than you — not only better photographers but also individuals who are better in their respective fields, no matter what they might be, than you are in yours. Learn to climb and use other people's ideas and attitudes as your ladder. Read good books, even if they are not literary. Our definition of a good book is one that includes as many ideas as possible that are worth stealing! Pay attention during movies — for ideas from camera angles, pacing, interesting images. Note them. Use them. As poet T. S. Eliot remarked: "Each venture is a new beginning, what there is to conquer has already been discovered, once or twice, or several times, by men whom one cannot hope to emulate, but there is no competition, there is only the fight to recover what has been lost and found and lost again and again."

Remember that the photographer's/artist's worst nightmare would be to reach the top of the ladder with nowhere else to go. The end.

Myth No. 7:
Critics and theorists are useful to photographers

Most colleges and universities do not hire the best in the field because these individuals are full-time photographers. Teachers are in the classroom, or at meetings, most of the time so all they can do is talk about photography. So it is not surprising that in academia has arisen a peculiar type of critical theory which young photographers are expected to apply to their own work and reference when discussing the work of others.

We have two attitudes to critical theory:

Attitude one: When critical theory is taught prior to or simultaneously with the making of images: in this case, critical theory is not only useless, it is also positively dangerous. It has nothing whatsoever to do with the production of fine photographs. The irony here is that most of the top photographers, often cited by the critics, have never read these theories, would not understand them even if they encountered them, and have no idea that such an influential group of thinkers exists in the medium! The dangerous aspect of theory for young photographers is that attempting to apply its precepts leads to total paralysis. We have both encountered many photographers who have completely dried up as image-makers in an effort to take pictures which conform to critical theories. Those who do not stop completely make very bad images which are then discussed/justified in blinding, mind-numbing jargon. There is a distinct correlation at work: the more the intrusion of critical theory before the act of photography, the worse the images will be.

Attitude two: When critical theory is taught after the images have been made or about other photographers' works: in this case, critical theory can be an enjoyable way of stretching the mind, if the critic is capable of thinking clearly and expressing his/her self with concise, vivid prose. Photography is a field with an infinite number of profound issues spanning sociology, history, psychology, biography, science, anthropology, and all the arts; each image can be a pebble — dropped in the pond of consciousness where the ripples eventually lap the very edges of human existence. Talking about these broader, deeper issues in the medium can be full of stimulation, inspiration and the sheer pleasure of working out in a mental gymnasium.

We say "can be" … usually critical theory is none of the above but an experience akin to wading in thick mud through a dense fog. It is no fun. The reason is that the language used by academic theorists in photography is so dense, obscure, jargon-filled and so damned dull that it is usually impossible to decipher the points that are being made.

Perhaps the issues are so profound that they cannot be expressed in clear, intelligible, vivid prose? Not likely. When scientists such as Stephen Jay Gould, Stephen Hawkins, Paul Davies, Lewis Thomas and Arthur Koestler can write about theories of life's origins, the nature of

time, quantum physics, the limits of the universe, the paradoxes of evolution, and similarly complex topics, and produce books of such dazzling appeal that they are best-sellers, are we really saying that photography is so much more profound that its issues cannot be explained in clear language? We think not.

Our conclusion is that critical theorists in photography cannot think clearly or write well. They have many excuses, we are sure, but the bottom line is that their essays are useless because they are unintelligible. But that is not a condemnation of the critical faculties applied to photographs. We hope a time will come when a Gould/Hawkins/Davies will turn their attention to photography. Meanwhile, we pass…

Myth No. 8:
You should not photograph in foreign cultures

A rising tide of political correctness threatens to drown the aspirations of photographers who wish to shoot pictures in cultures not their own, either at home or abroad. The rationale for this notion is that you cannot fully understand another culture, or race, or ethnic group, unless you were born in it. The photographs you take, therefore, will be exploitive because they will not be truthful.

There are several problems with this seemingly liberal idea, and the most important is that *people are far more alike than they are different.* The idea that photographers should not photograph people of different cultures presumes that the "differentness" is *the* major issue. In our opinion this notion is not only false but also it is divisive and verges on racism. Human beings share more in common with each other than the myth allows, and photographers are in a unique position to explore, spread and celebrate the one-ness of our existence.

If the truth is elusive when photographing other cultures, then it is equally exploitive, for the same reasons, to photograph people in different economic brackets (higher, as well as lower), people of the opposite gender, people of different ages, and people who look different to you. Taking the argument to its logical conclusion, you should not photograph anyone. And there does exist an attitude among some critics that all photographs of other human beings, especially those taken unawares, are not only unethical but (should be) illegal. The idea is that everyone owns their image, even if that constitutes merely the light reflected off a solid surface. (This notion would wipe out the vast majority of fine photographs which have been taken since the 1880s.)

And it would wipe out all the social benefits which have accrued from humanistic photography, from Lewis Hine's work with the Child Labor Committee, to W. Eugene Smith's expose of toxic waste dumping in the Bay of Minimata, to Sebastião Salgado's images which brought to world attention the slave conditions in Brazil's mines. The list would be endless — and

include the photographers' images which were instrumental in turning the tide of public opinion against the Vietnam war.

But even if all these social benefits of reportage photography did not exist or could be explained away, there remains a fundamental flaw in the myth: photographers never claim to tell the truth. Period.

The best photographers have an intense interest in and enthusiasm for their subjects (which precludes deliberate exploitation) and they have researched and read and talked until they are mini-experts in the area. All they claim is: "This is what I saw. This is what I felt about what I saw — at the time I was taking the pictures. This is my point of view. This is an individual truth, to the best of my ability." It will never be everyone else's truth.

David: I was the one who discovered my mother after her death. She had died of natural causes and had a smile on her face. I wanted to remember that smile and so took a picture — just one. The picture has no relevance to anyone but me and consequently would not be shown to others outside the immediate family. However, for me, it is the most important picture I have ever taken. Over the years I had amassed a large number of photographs of this remarkable woman and decided to print up a coherent set, which I showed to the rest of the family. I was amazed to find that each in turn would remark, as they looked at different images, that this one or that one really captured her, was "just like her." But the choices of the family members were never the same, each viewer had a personal preconceived notion of what was the truth. At this point I clearly realized that there is no universal answer, or agreed truth, even with a subject on which all the viewers were extremely knowledgeable. Each viewer brought to the photograph his/her own truth.

Our advice to photographers is: do your homework, examine motives, be clear about the purpose of the pictures, make no exaggerated claims towards omniscience — and ignore the myth.

Myth No. 9:
Documentary photography is not art

Don't panic — this will not be a treatise on the various definitions of art in an effort to force photographs into an odd-shaped pigeonhole. Instead, we want to offer a few words of consolation to photographers, perhaps struggling in an art-academic environment, who are feeling a sense of inadequacy in their straight photography when surrounded by the transformations of the medium practiced by artists. It is our contention that much of the confusion surrounding art and photography would dissipate by bearing in mind two simple statements:

Art is not the medium or style but the agreed merit of a body of work created over a life-time of achievement by a dedicated individual.

This body of work is likely to center around the unique characteristics of the chosen medium.

Both statements could be expanded, amended, reconfigured and analyzed *ad infinitum, ad nauseam*, but they do serve to clarify certain problems and dispel the myth under discussion.

Today, especially in art environments, the photographer is urged/expected to emphasize individuality. Can reportage photography reveal such personal idiosyncrasies? The clear answer is that it is impossible to keep them out of the images. You select a subject for which you have interest and enthusiasm; you choose how best this subject is revealed by camera viewpoint; you decide on the precise moment when it is most significant — all these are very subjective, personal decisions.

Indeed, it is our contention that the self is more emphatically expressed by ignoring it and concentrating on the thing itself. Personal knowledge is gained by objectification, looking outward not inward. Life itself is the mirror in which the personal image is reflected.

Is there any evidence for these assertions? Look at large bodies of work by the finest reportage photographers and you quickly discover that it is easy to distinguish the individual styles and concerns. That should come as something of a shock if reportage photography is only an impersonal, objective reflection of reality.

Another experiment (hypothetical, this time): let us suppose you could ask 100 of the best critics, curators, historians, museum directors and photographers to each select the 50 greatest images in the history of the medium. Our guess is that the vast majority of these 5,000 images would fall under the general category of straight, documentary or reportage photography.

These remarks are not intended to disparage the work or ideas of the painters, sculptors and print-makers who utilize photographic images. That is a legitimate and sometimes fascinating process for producing visually stimulating works of mixed-media. But it is not photography.

We believe that photographers of all personality types, using the whole panoply of camera formats, would become better photographers at a faster rate by employing the common denominators gleaned from the images, ideas and lives of the best photographers throughout the medium's history. These basic principles are:

> *1. Photographers are not primarily interested in photography. They have a focused energy and enthusiasm which is directed at an outside, physically present, other. They bring to this subject an exaggerated sense of curiosity, backed up by knowledge gleaned from reading, writing, talking, note-taking.*

2. The photographer transmits this passion in "the thing itself" by making pictures, therefore the subject must lend itself to a visual medium, as opposed to, say, writing about it.

3. The photographer must assiduously practice his/her craft so that there is no technical impediment between realizing the idea and transmitting it through the final print.

4. The photographer must have the ability to analyze the components of the subject-idea so that a set of images not only reflects the basic categories but also displays visual variety. Intense, clear thinking is a prerequisite to fine photography.

5. The photographer is aware that, like all difficult endeavors, to be good at photography requires an unusual capacity for continuous hard work and …

Good Luck.

About the Authors

David Hurn

David Hurn has achieved international renown across a wide range of professional photographic activities. As a hard news photographer he 'cut his teeth' at the Reflex Agency as a protégé of Michael Peto. He soon turned freelance and covered major topical events, including the Hungarian Revolution for *Life*, *The Observer* and major magazines and newspapers throughout the world.

He began to shoot special projects on major movies, which in turn led to a brief, but lucrative, period as a fashion photographer for *Harpers*, *The Telegraph* and *Jardin des Modes*.

But it was the feature essay which was his first love. He worked on many assignments concerning what is now known as alternative lifestyles, often with brilliant writers such as Nell Dunne and Irwin Shaw. It was these essays which brought him to the attention of the world's most prestigious photographic collaborative, Magnum Photos, Inc. He was invited to become a Full Member in 1967.

In 1970, David Hurn founded The School of Documentary Photography in Newport, Wales. Since 1990 he has returned to fulltime photography, producing self-assigned major essays for both publication and exhibition. In 1999 the National Museum of Wales gave him their Millenium exhibition.

Bill Jay

Bill Jay began his career in England where he was the first Director of Photography at the Institute of Contemporary Arts and the first editor/director of *Creative Camera* and *Album* magazines. During this time, he earned a living as Picture Editor of a large circulation news/feature magazine and as the European Manager of an international picture agency.

After studying with Beaumont Newhall and Van Deren Coke at the University of New Mexico, he founded the program of Photographic Studies at Arizona State University where he taught history and criticism classes for 20 years. He is now retired.

Bill Jay has published over 400 articles and is the author of more than 15 books on the history and criticism of photography. Some of his recent titles include: *Cyanide and Spirits: an inside-out view of early photography*; *Occam's Razor: an outside-in view of contemporary photography*; *USA Photography Guide*; *Bernard Shaw: On Photography*; *Negative/Positive: a philosophy of photography*, etc.

Bill Jay is a frequent guest lecturer at colleges and universities in Britain and Europe as well as throughout the USA. His own photographs have been widely published and exhibited, including a one-person show at the San Francisco Museum of Modern Art.